To my friend and fellow artist...

Billy
Have fun drawing!
Gary Harbo
2010

Love
Uncle Jon
and
Aunt Tracy

How to Draw 104 Cartoons
with Gary Harbo

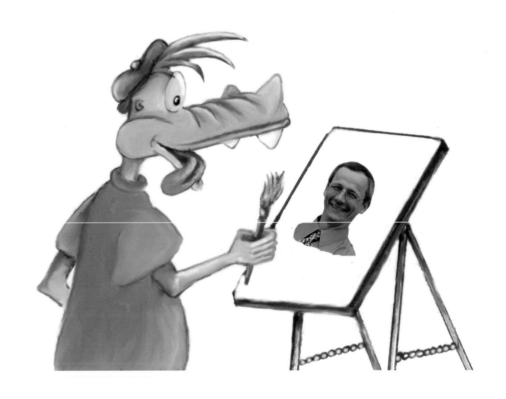

Created by Gary Harbo

How to Draw 104 Cartoons
with Gary Harbo

Published by KUTIE KARI BOOKS, INC.

Printed in the United States of America, in North Mankato, Minnesota
082809
20090801

ISBN 978-1-884149-34-4

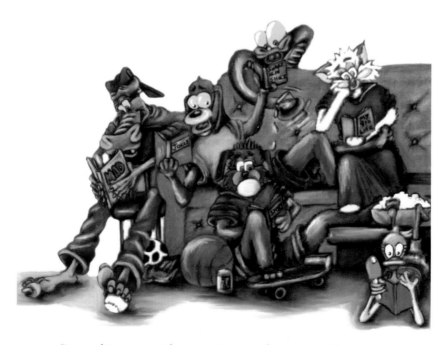

Reading.... Share it with your friends!

Dedicated to my Mom

Janet Marie Harbo

You believed in me even when I did not believe in myself. Thank you for inspiring me to dream big, follow my passion and to never give up.

Welcome fellow artists!

My name is Gary Harbo and I welcome you to the wonderful world of drawing. I'm an artist and I love to draw. It doesn't matter what age you are, or how good you are at drawing, everyone can become a better artist.

Each time I begin a picture, I find that it's an adventure. In all honesty, I am not completely happy with every picture that I draw. For every book that I illustrate I actually draw each picture at least twice before I finally feel that I got it right.

Over the years I have learned that the best way to become a good artist is to practice. If you want to become a great artist, then you have to practice, practice, practice...

You will find this book to be different from most drawing books. I feel that it works best to break any drawing into a step-by-step process. Don't let a big complicated picture overwhelm you. Every picture is created one step at a time.

The most important step is the first one. Don't worry about being perfect. Nobody draws a picture perfectly the very first time. The key is to draw it the best that you can, learn from the steps, and practice drawing it again. You will get better!

Have fun and don't take it too seriously. Draw each of the characters in the book. Practice coloring them with colored pencils.

Remember, everyone has their own style. Thank goodness! **If we all drew exactly the same way, it would be a boring world.**

Tips on drawing

1. Always use a pencil.
 Never use a pen, marker or colored pencil to draw with.

2. Keep your pencil sharp.

3. Draw lightly and never press hard.
 This makes it easier to fix mistakes by erasing.

4. Keep your eraser clean.
 Don't let it get covered with lead.
 Use an extra sheet of paper to rub your eraser clean.

5. Use nice paper that works well for drawing.
 I use Bienfang Heavyweight Drawing 70 pound.

6. Don't get too hung up and erase too much in the same area.
 We all know what happens to paper when we erase too much.

7. Make sure to draw your picture large.
 Artists draw large to make it easier to color and add detail.

8. Always sign your artwork.
 That is your copyright protection.

9. Always date your artwork.
 That allows you to see how you progress over the years.

10. Don't give up. The more you practice, the better you will get.

Gary also has 6 hardcover picture books for ages 2-6 and 7-11:

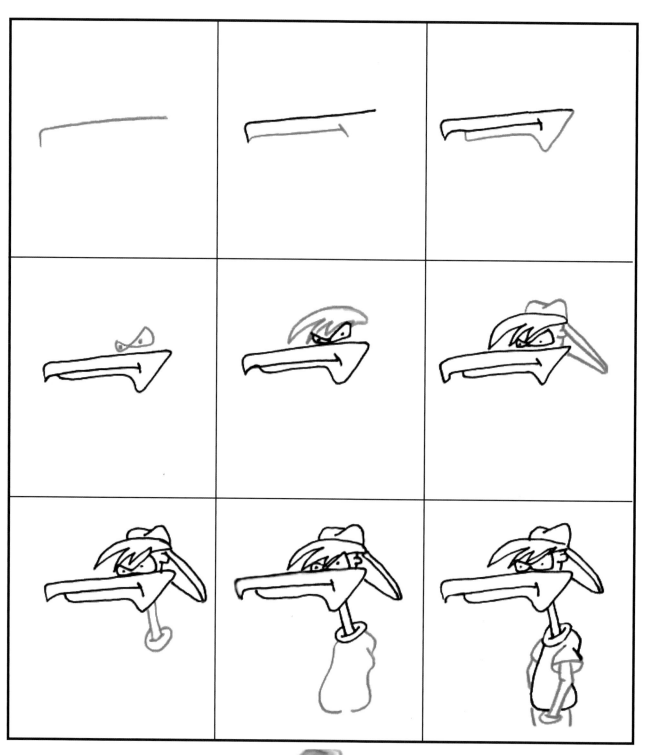

1

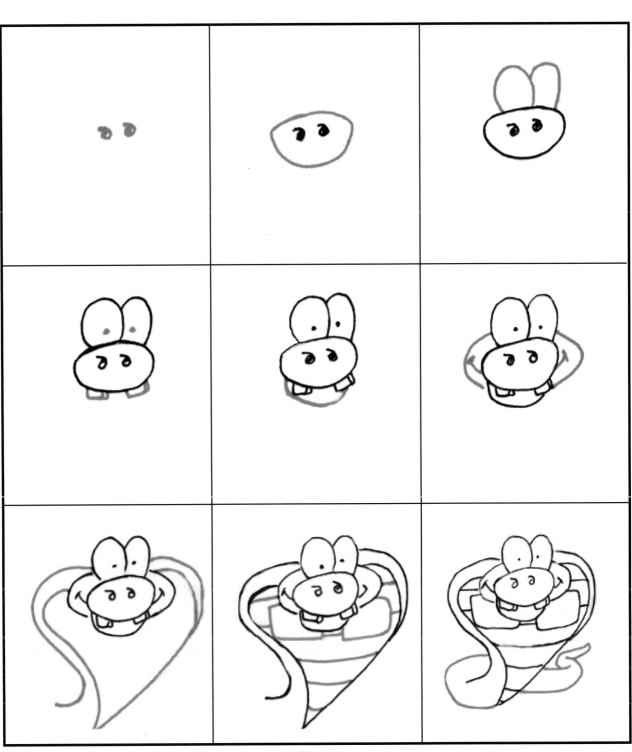
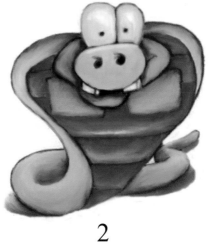

2

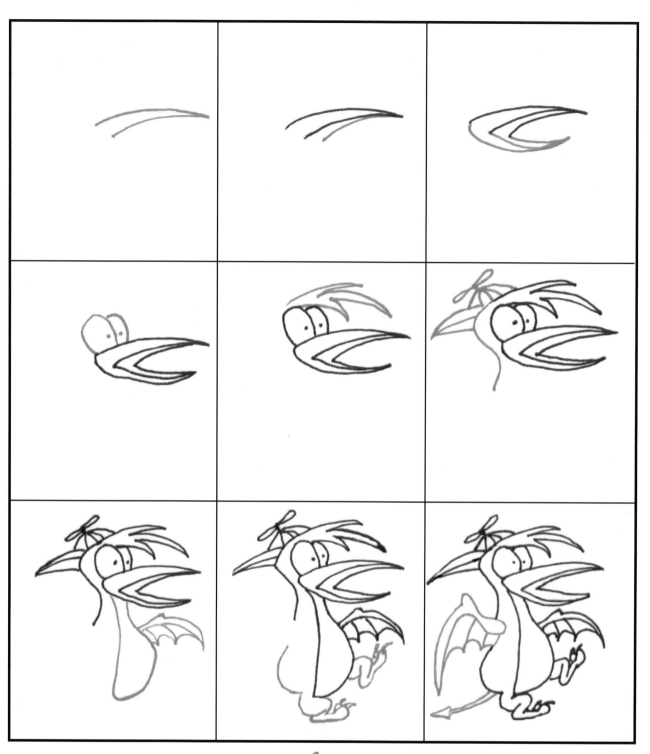

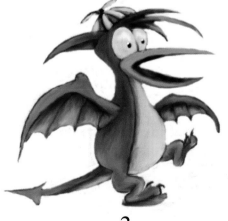

3

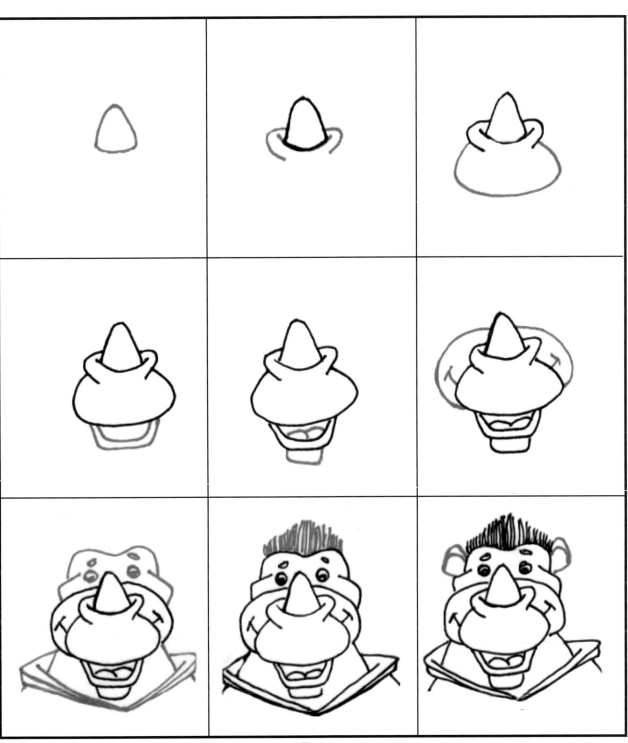

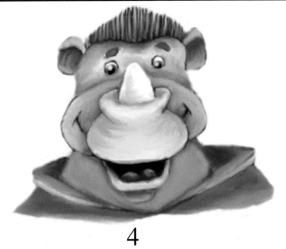

4

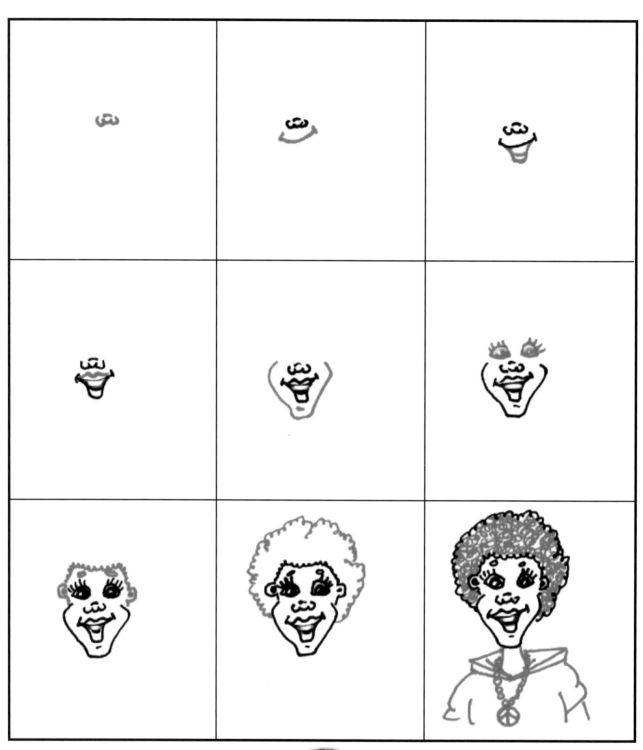

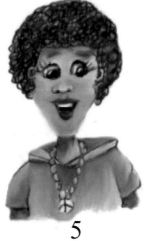

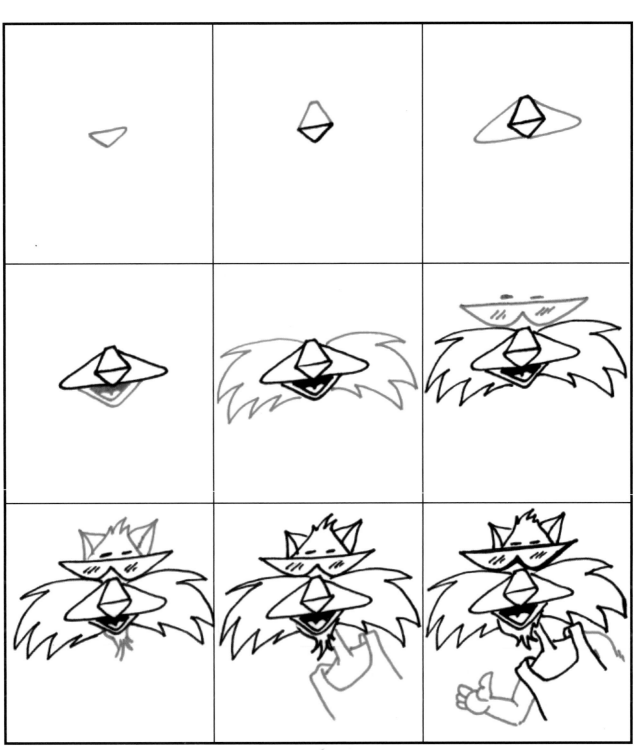

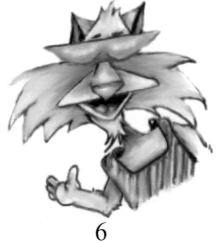

6

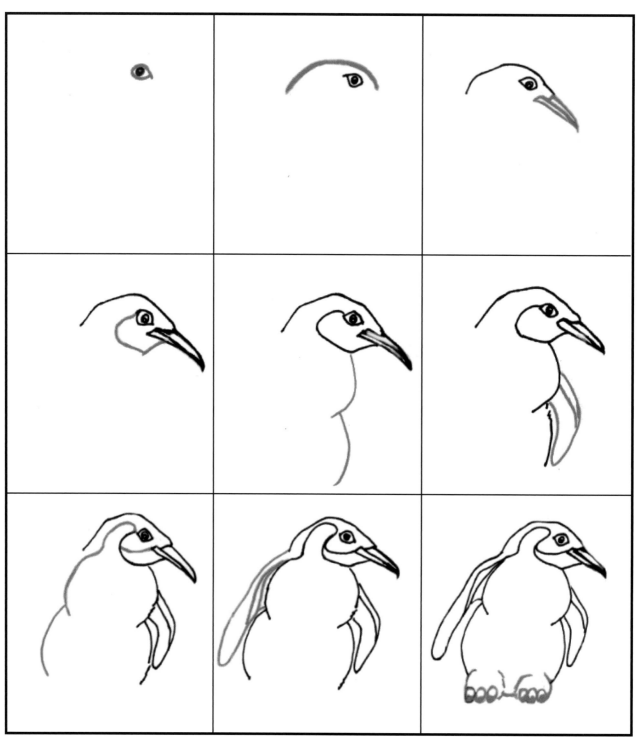

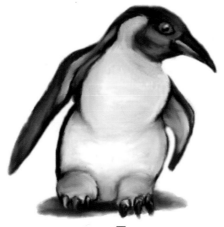

7

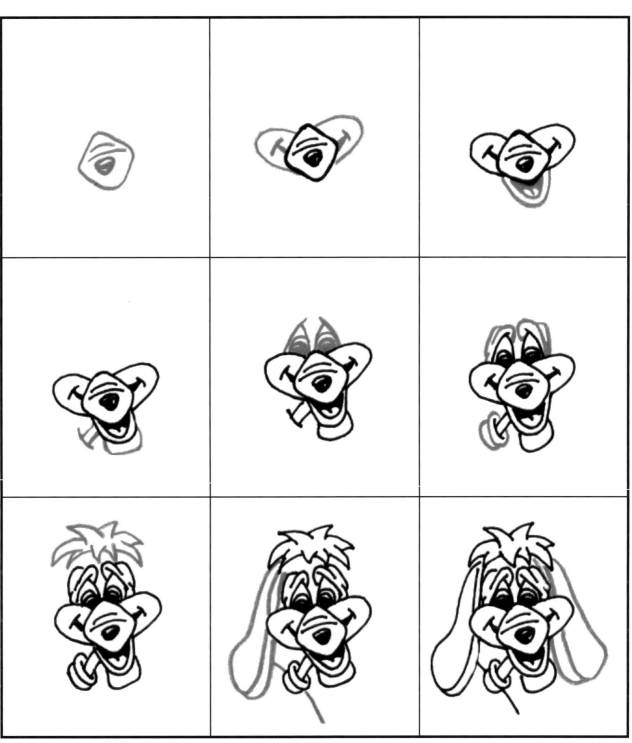

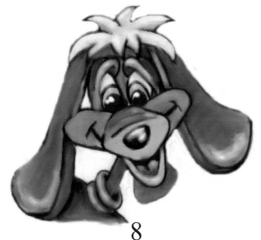

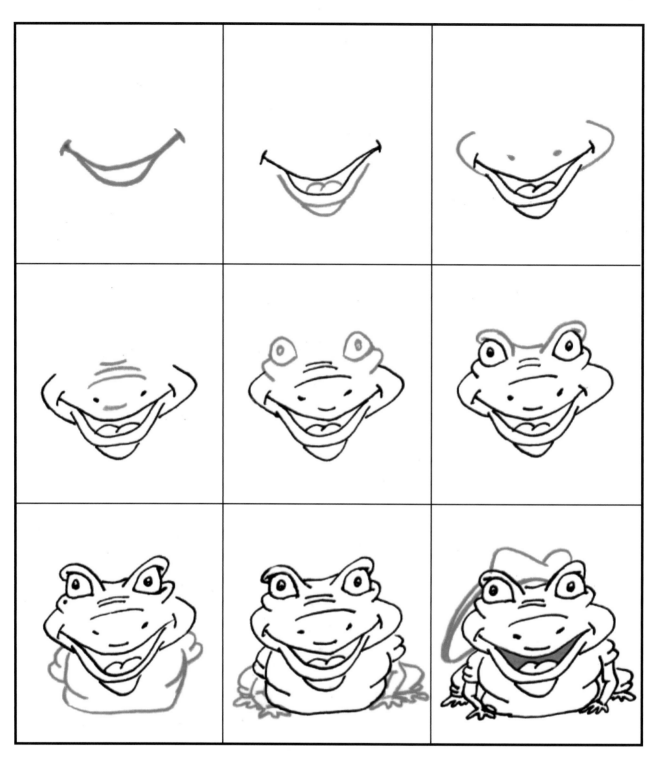

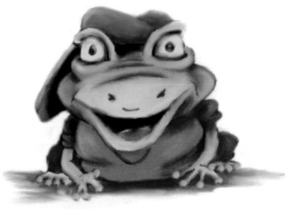

9

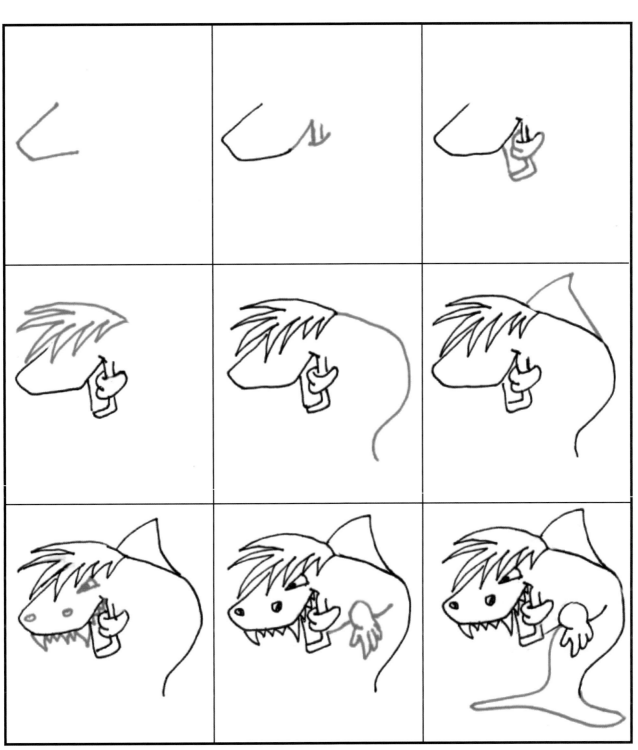

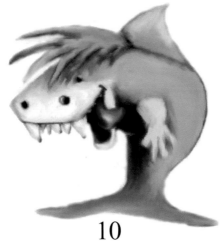

10

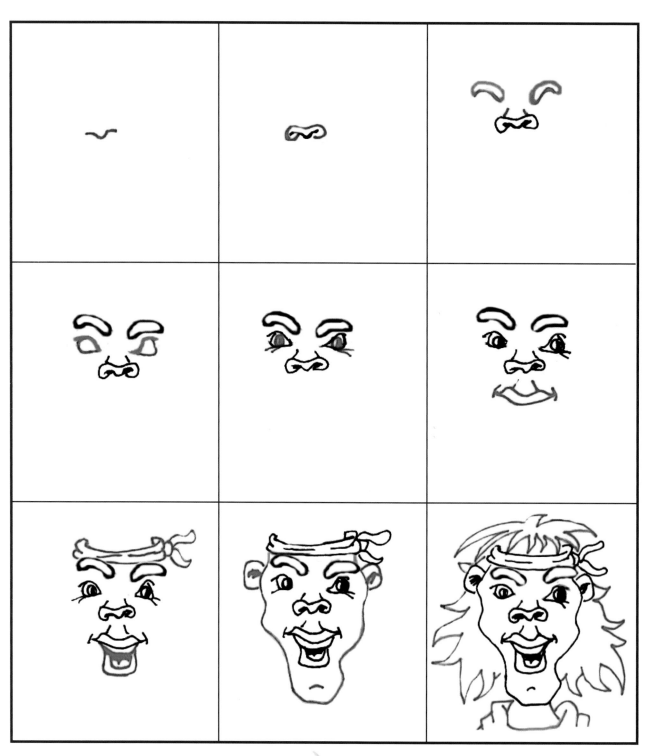

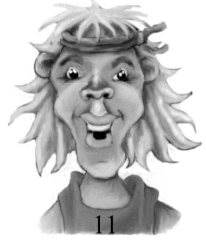

11

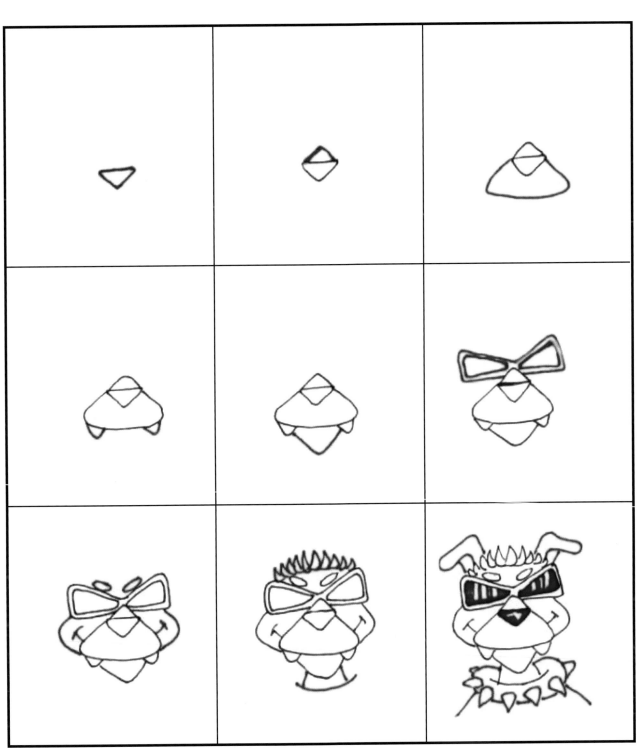

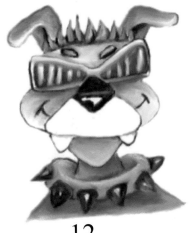

12

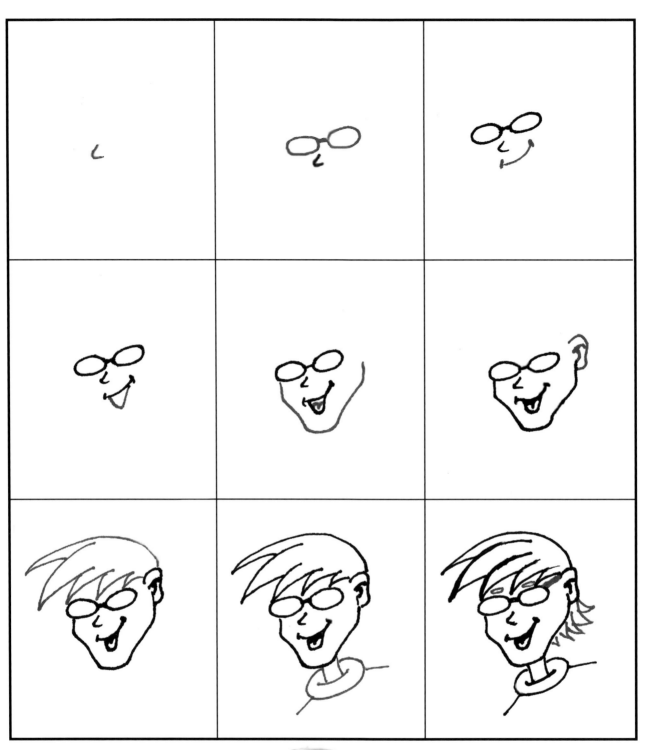

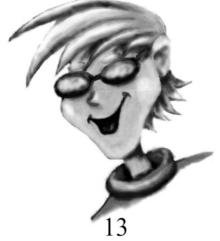

13

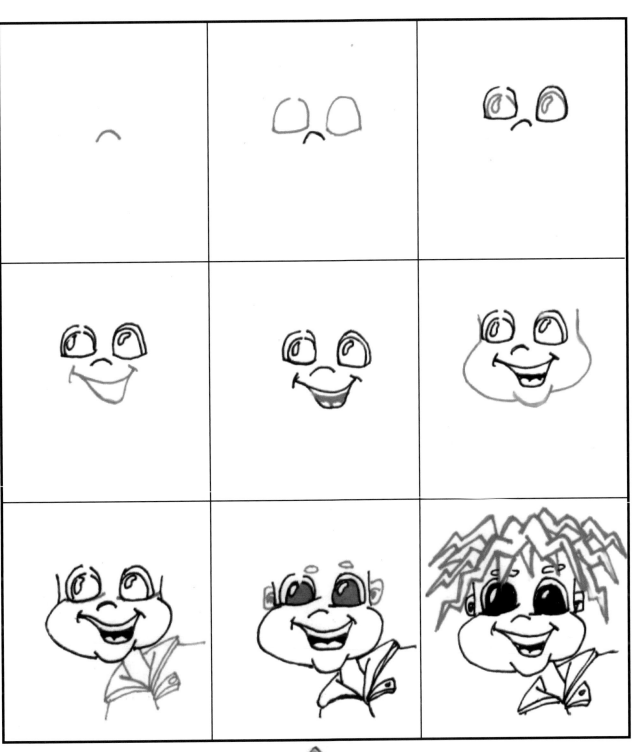

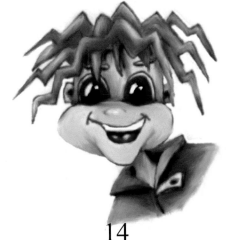

14

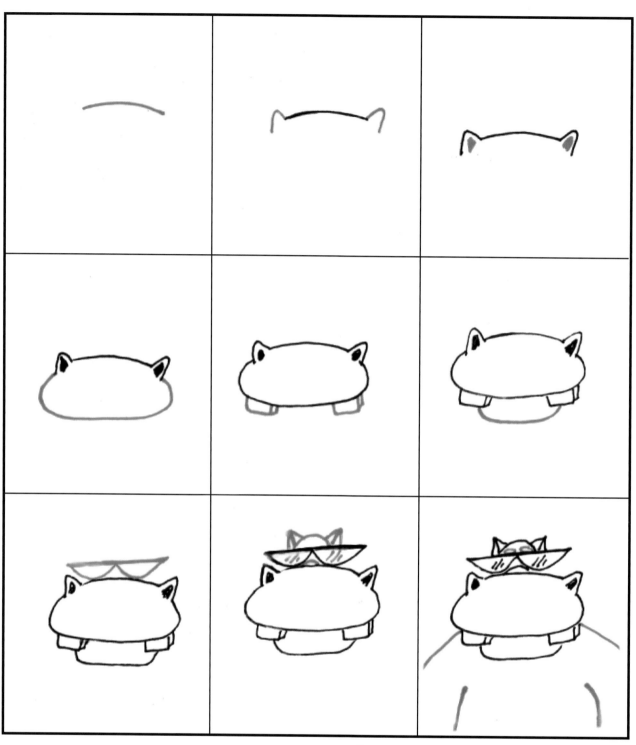

15

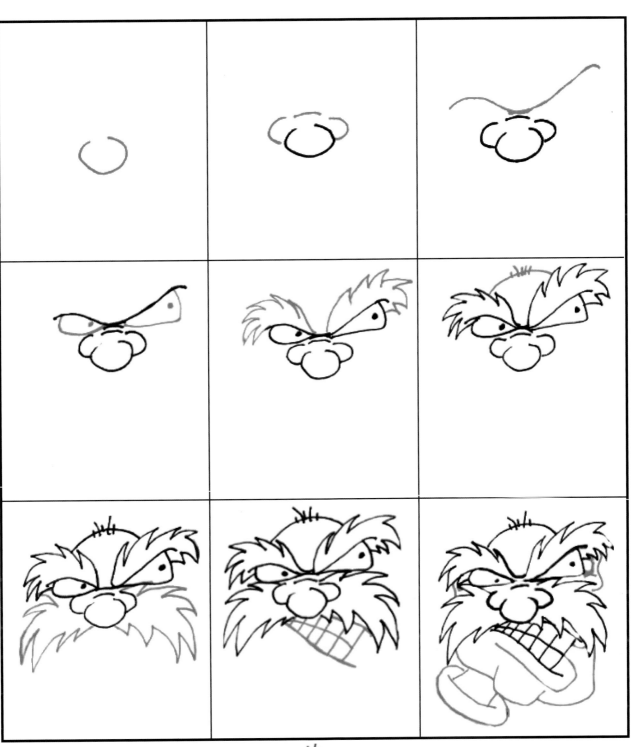

16

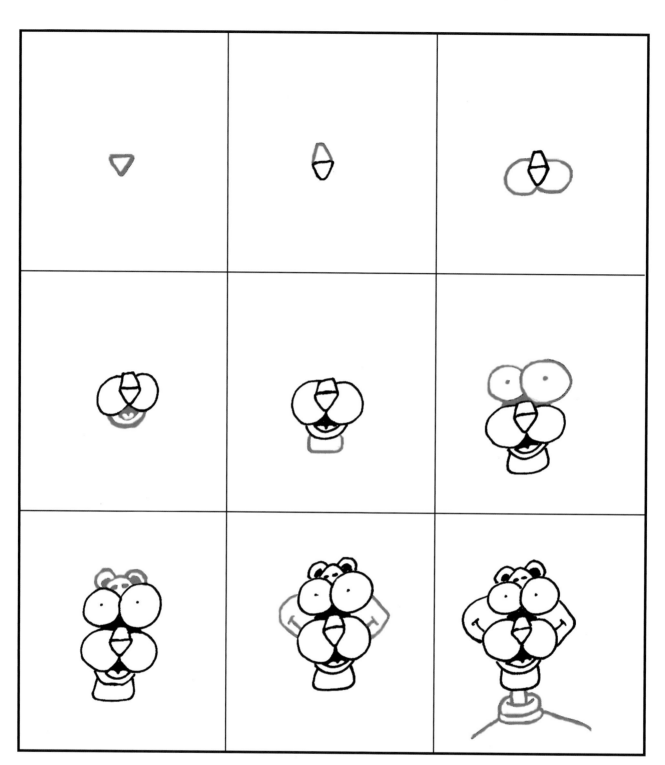

17

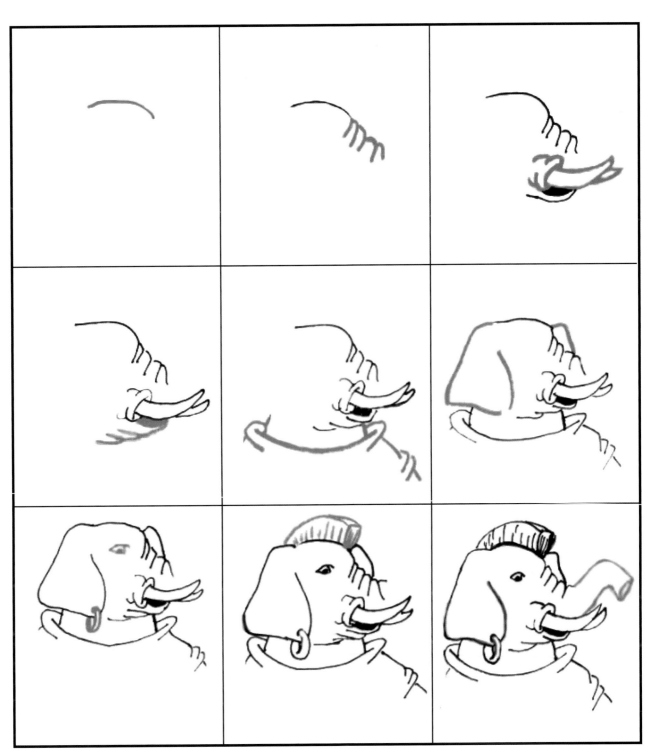

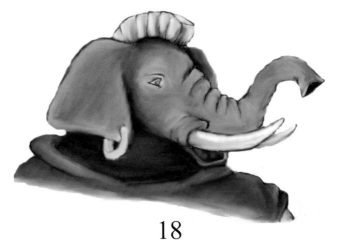

18

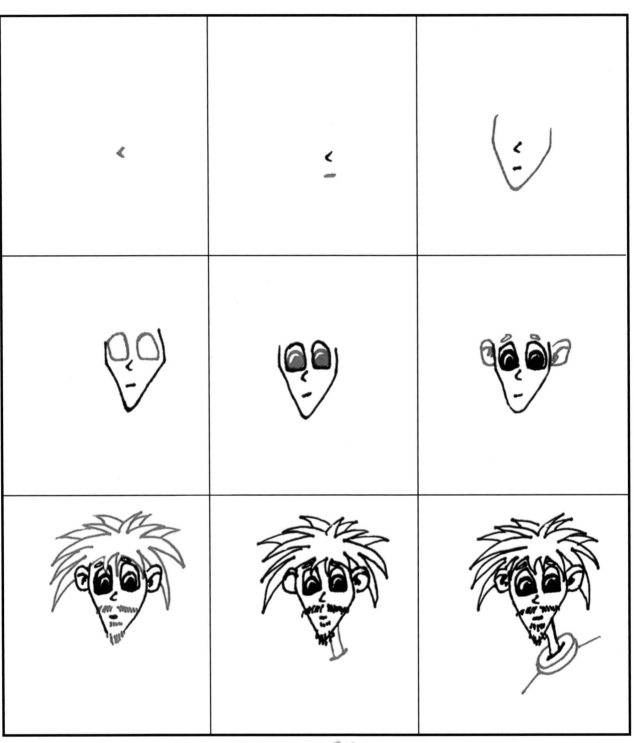

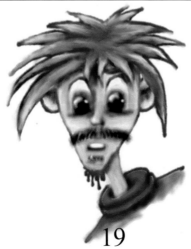

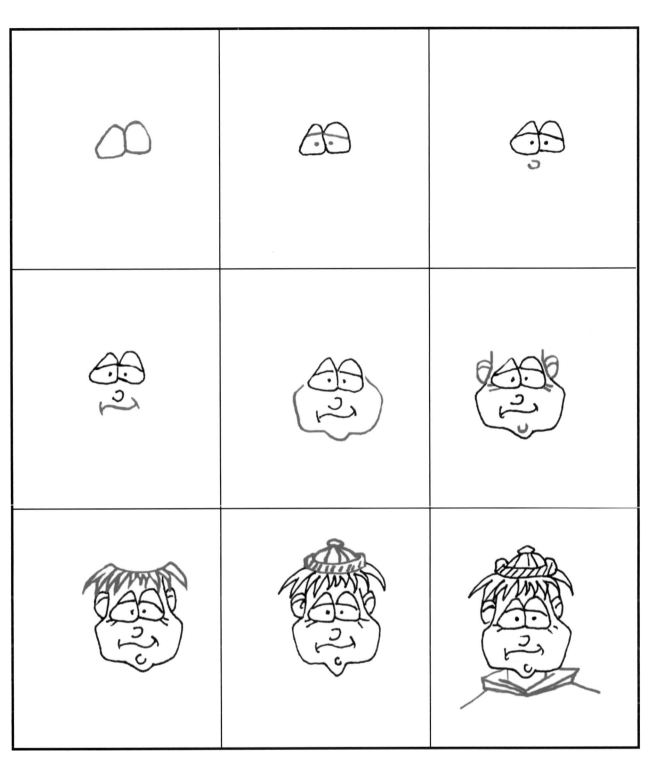

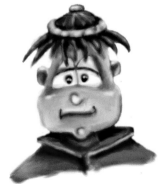

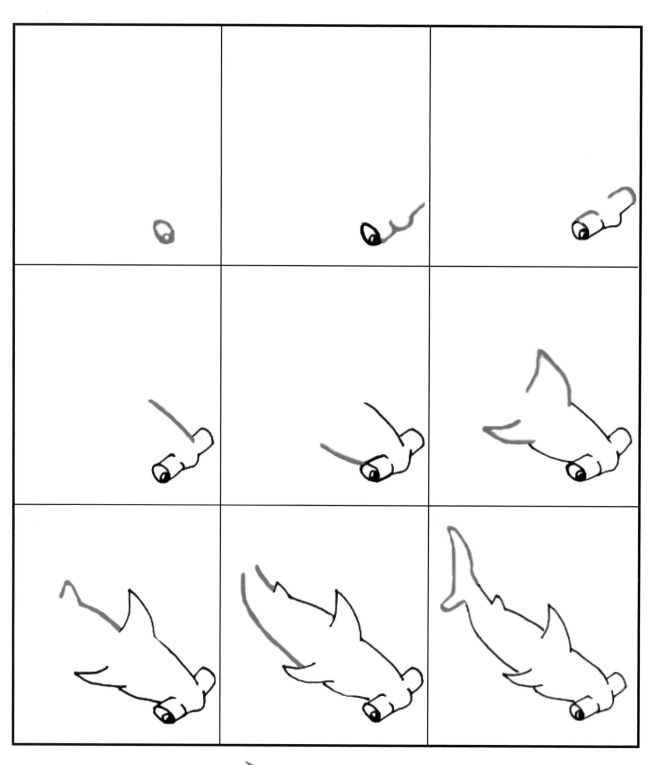

21

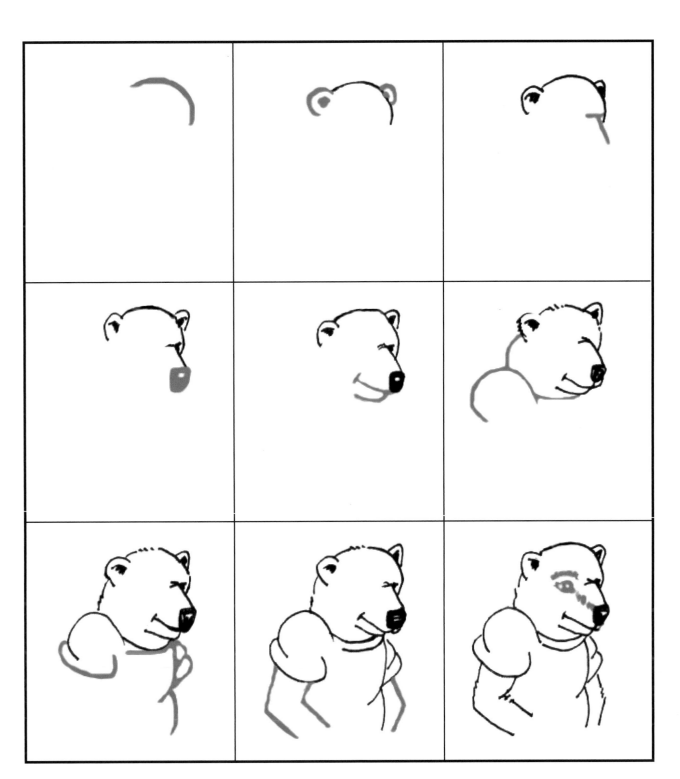

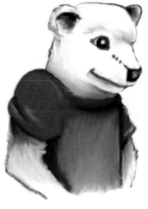

22

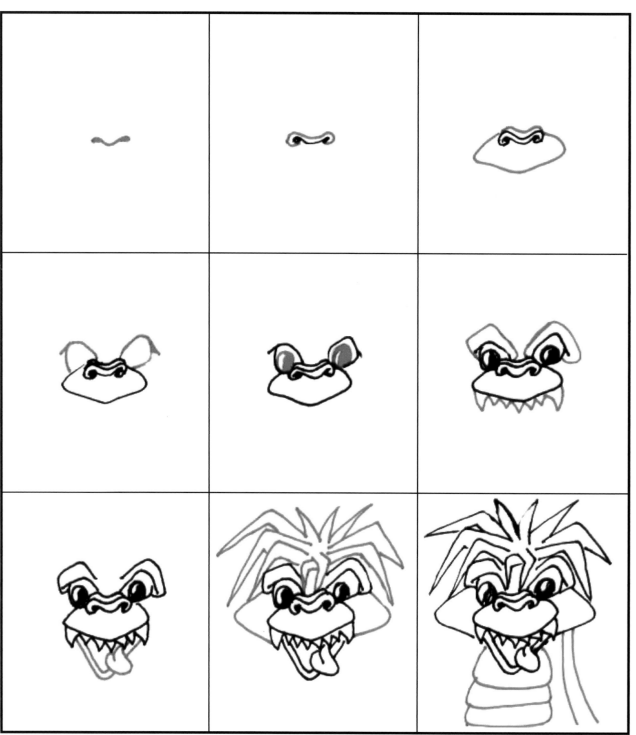

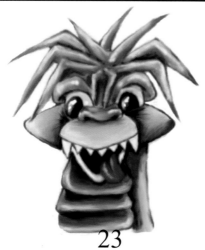

23

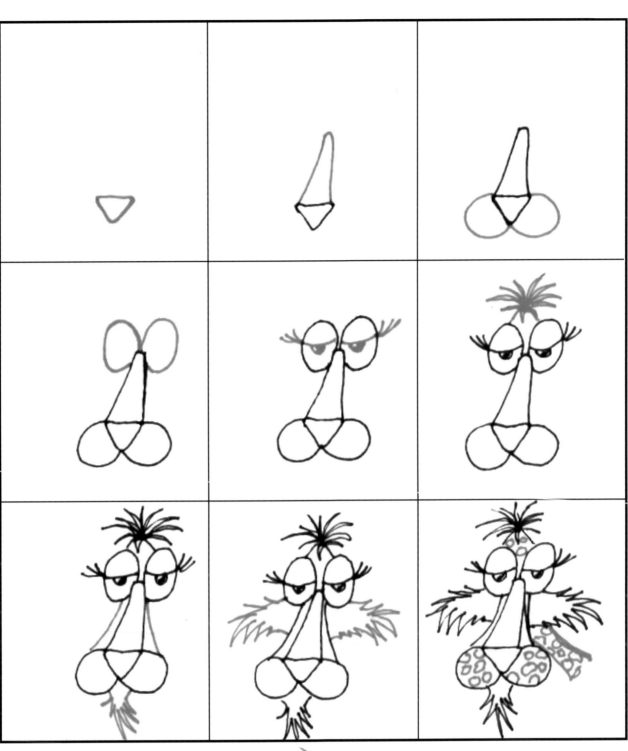

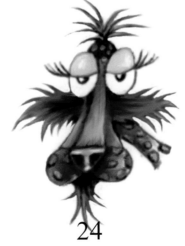

24

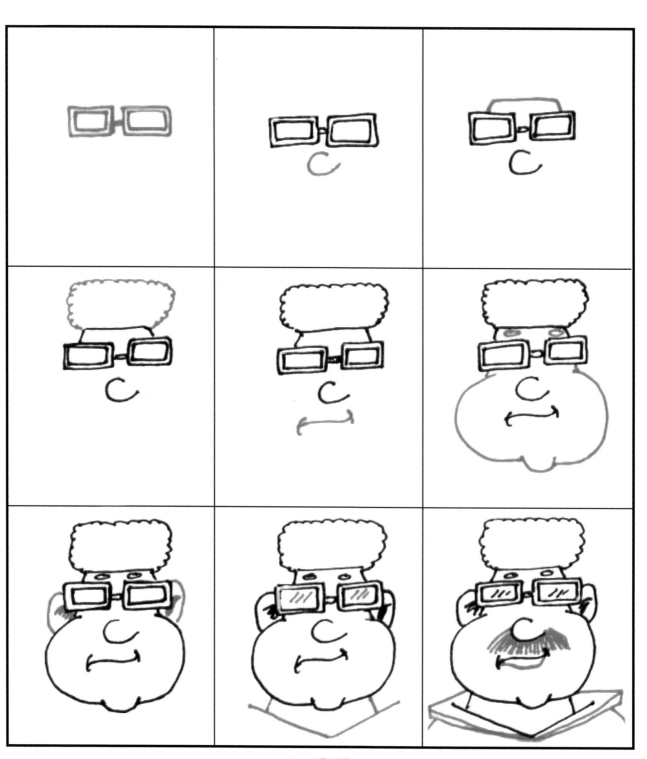

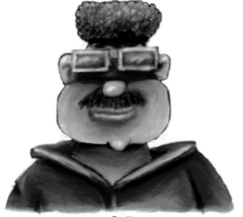

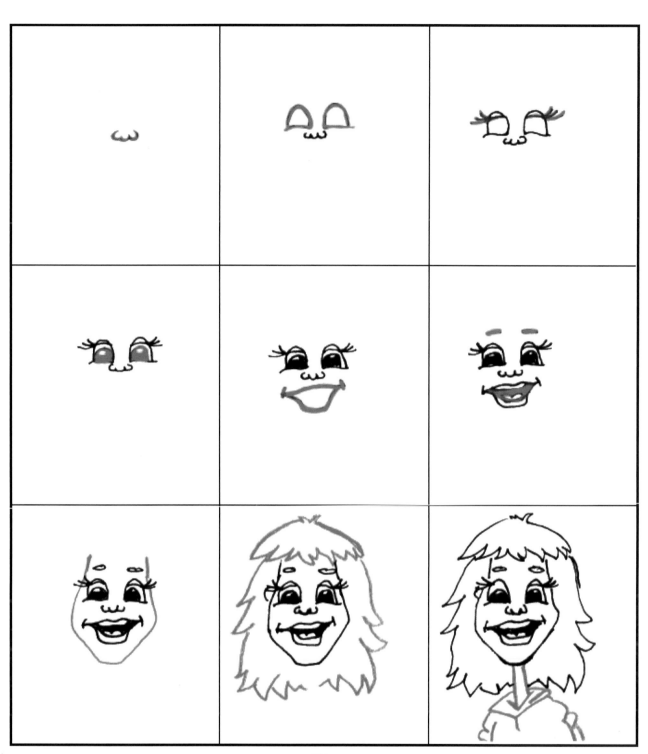

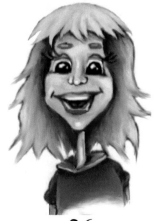

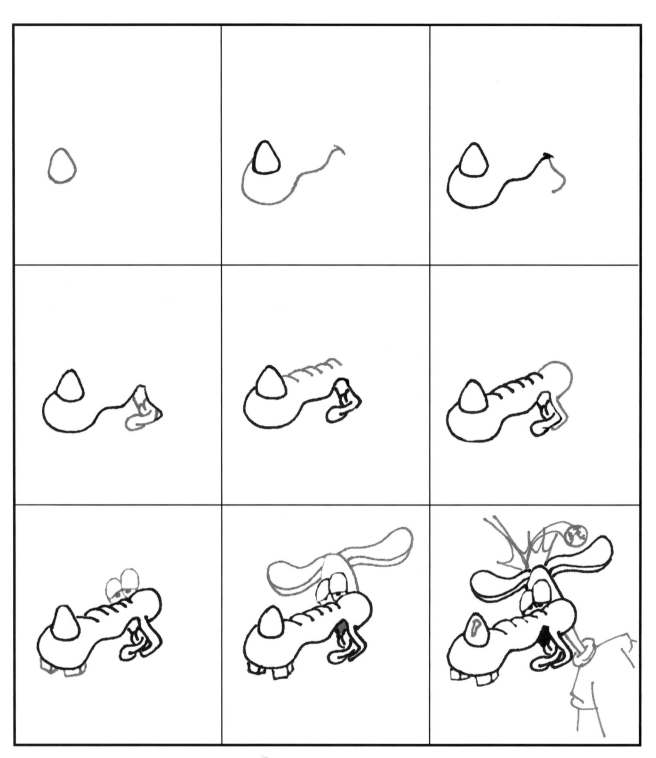

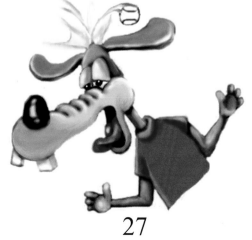

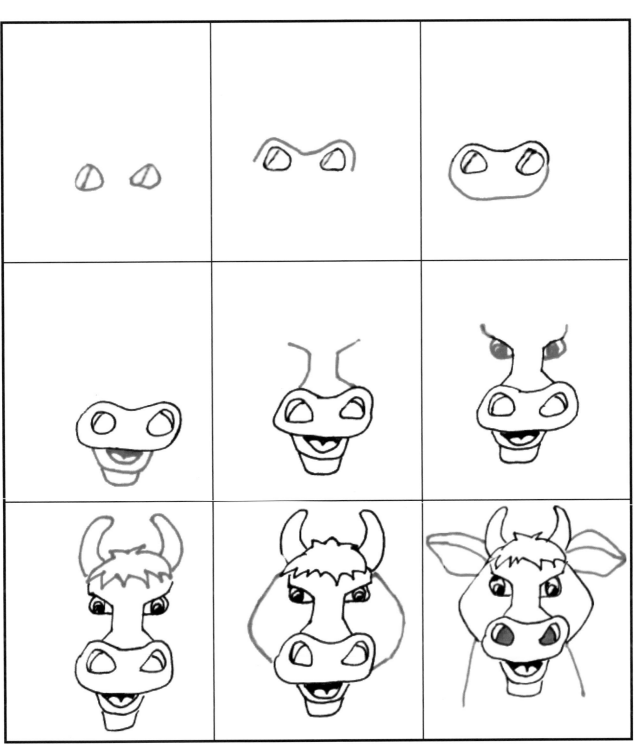

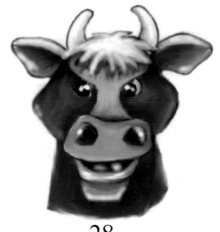

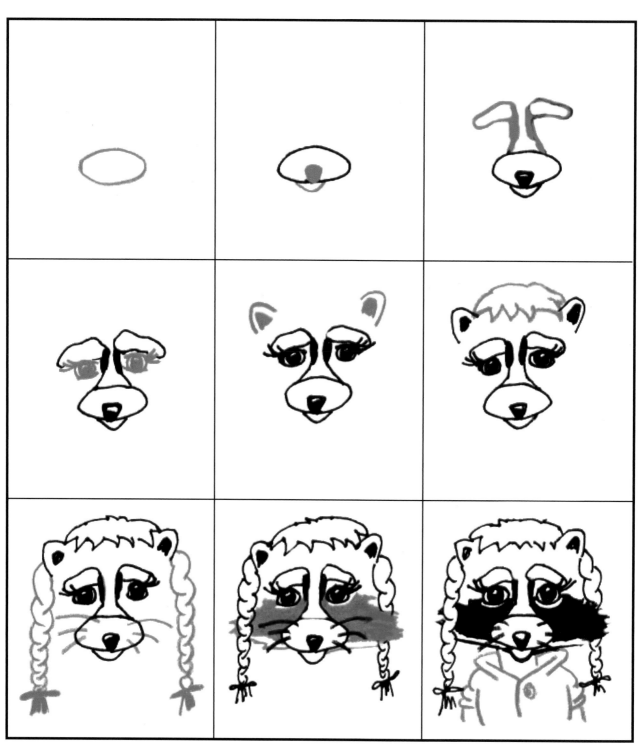

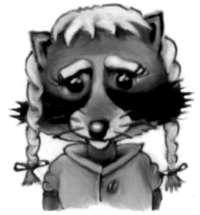

29

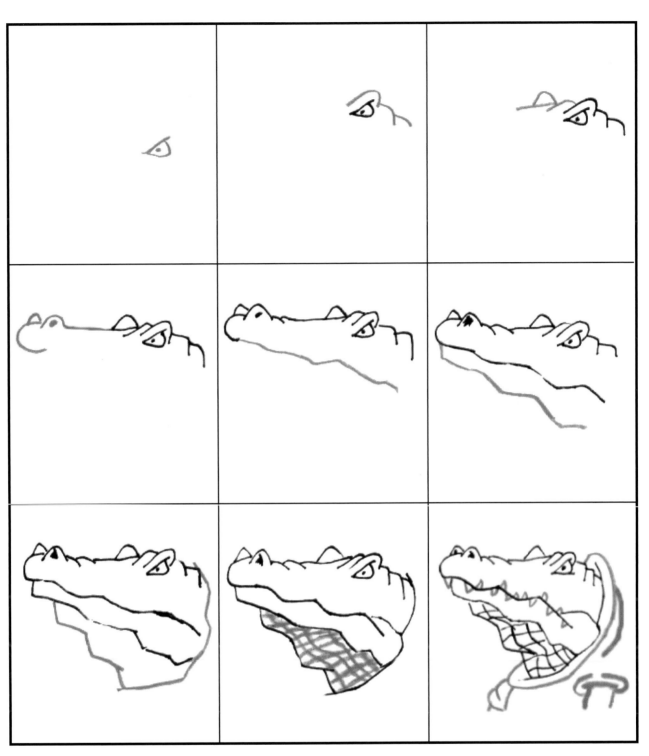

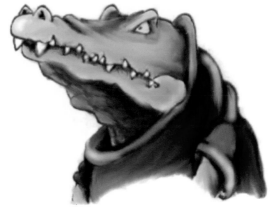

30

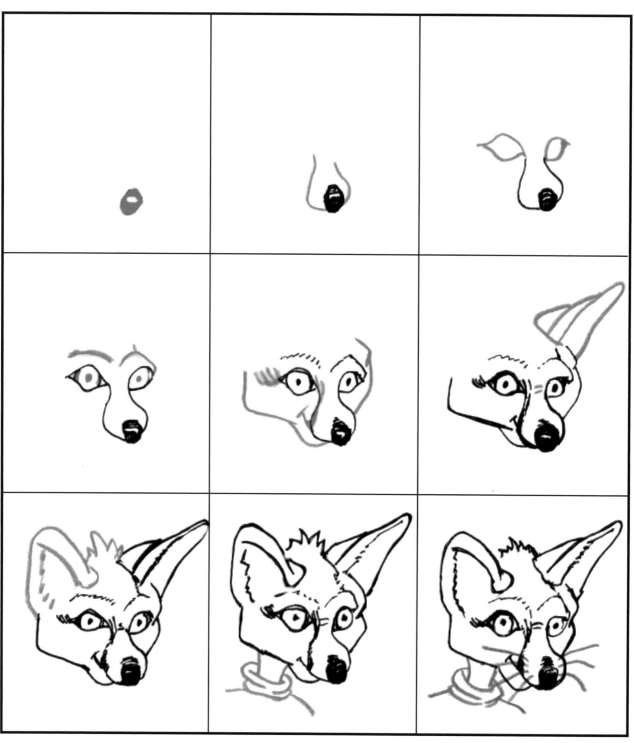

31

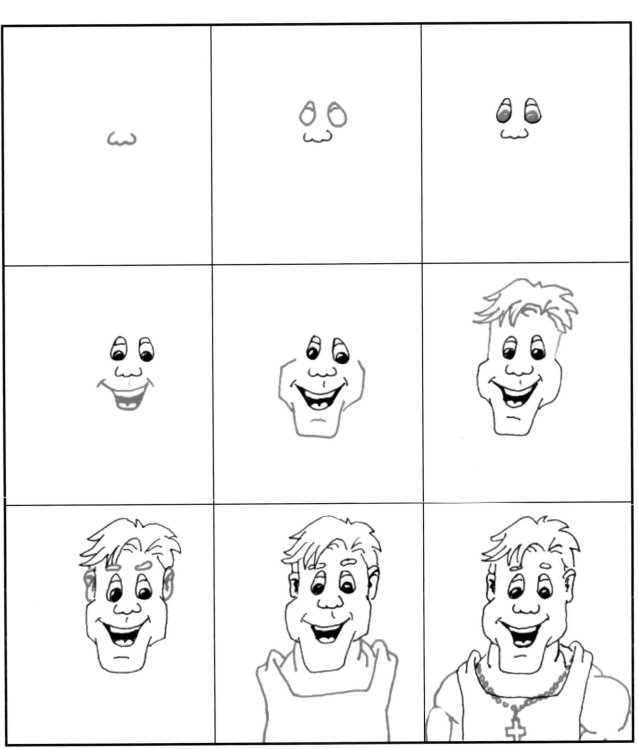
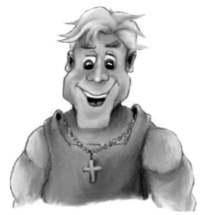

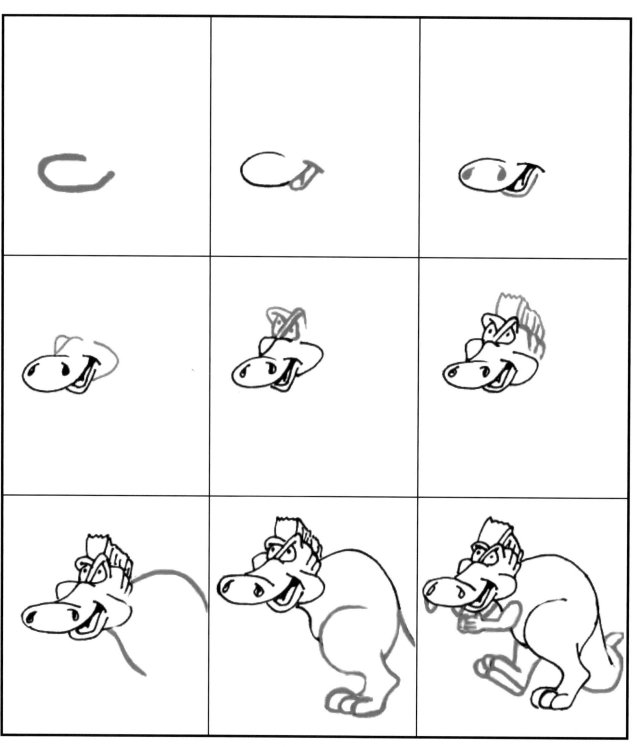

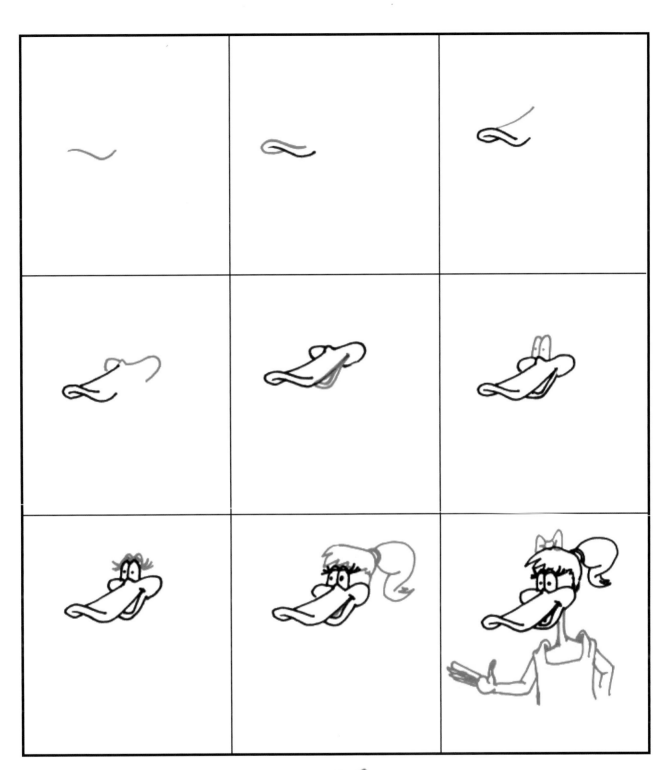

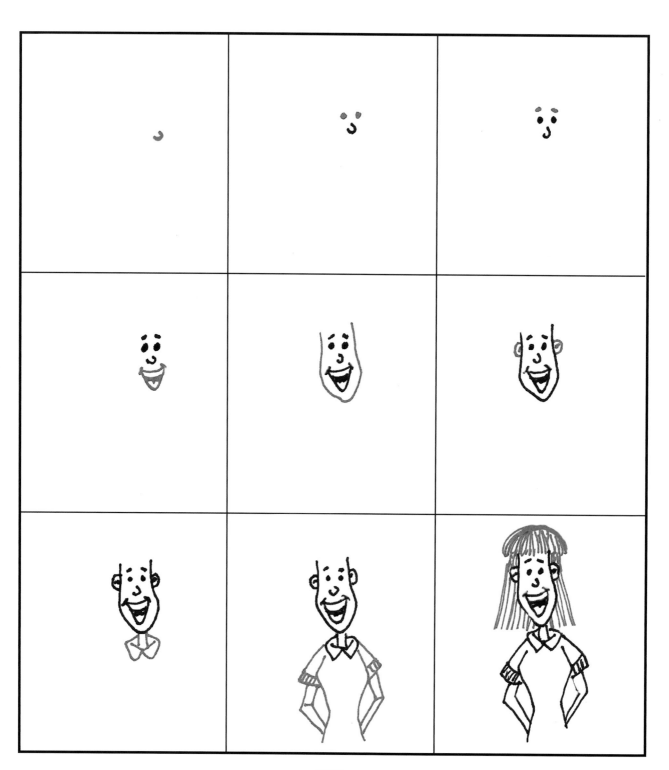

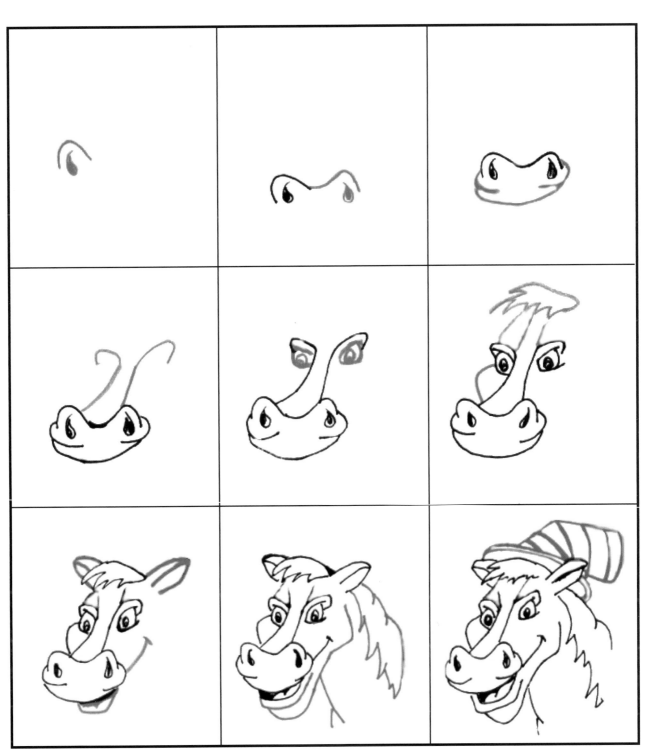

36

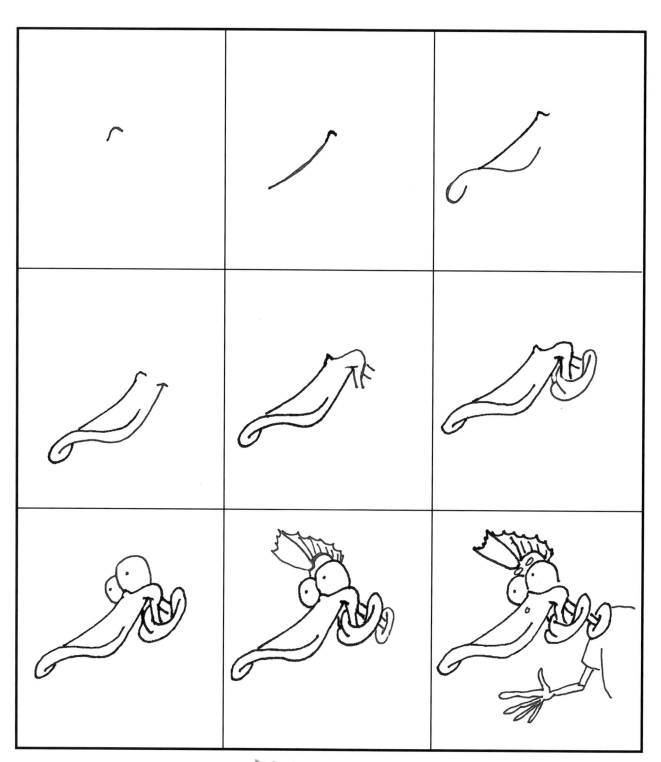

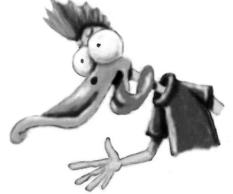

37

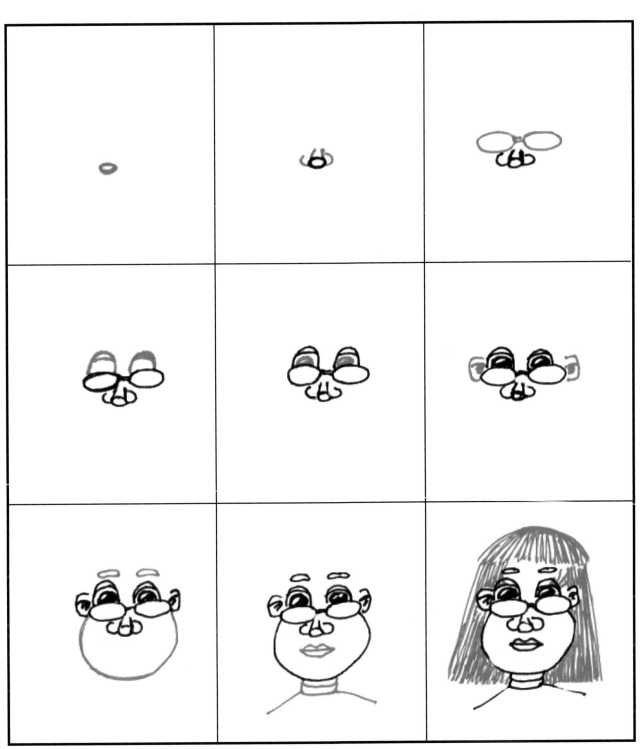

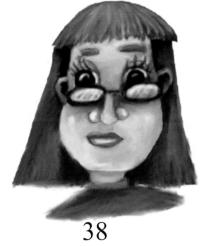

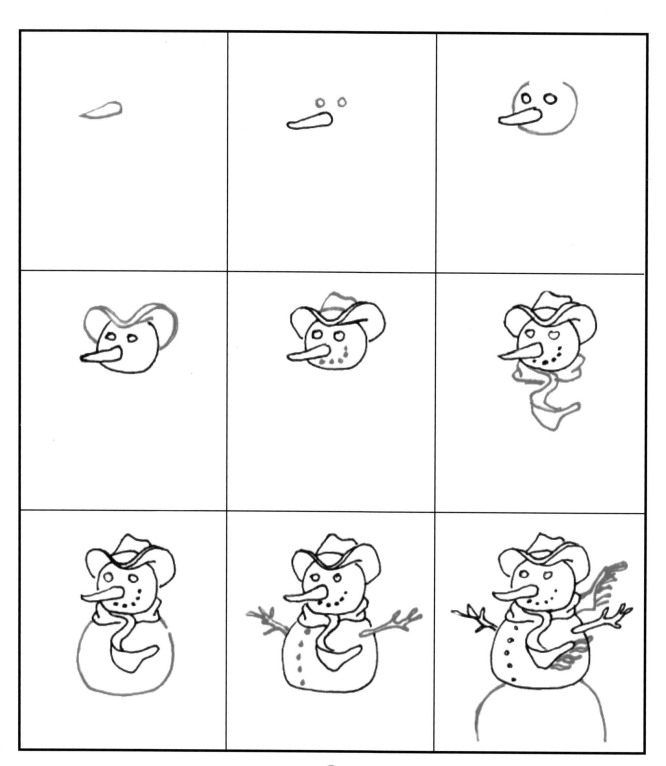

39

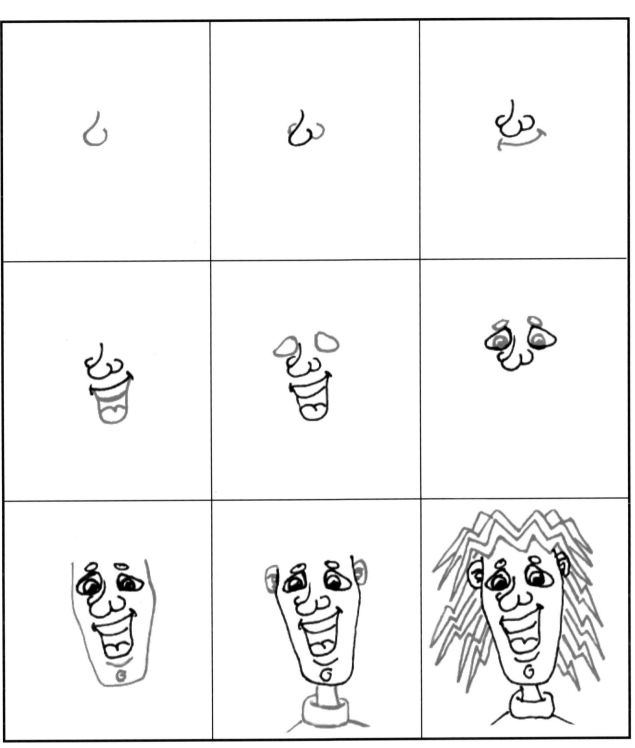

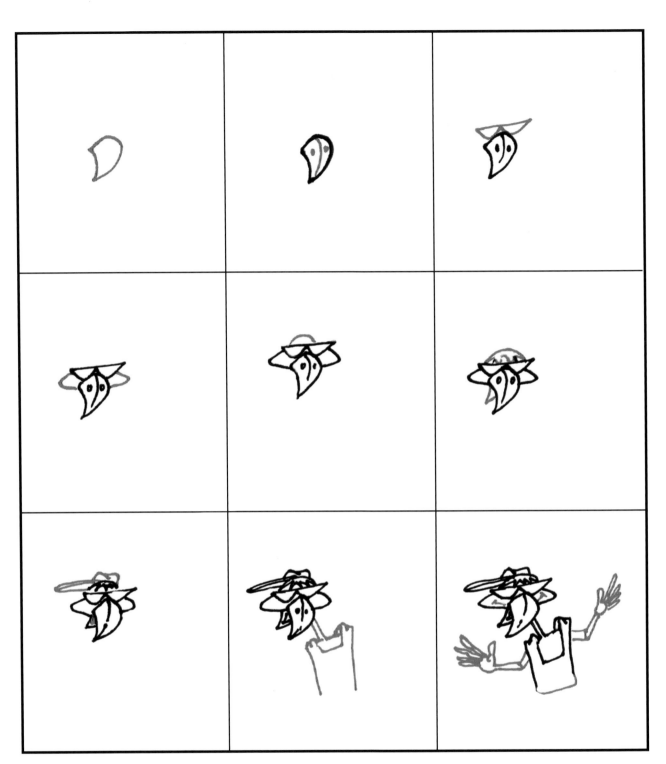

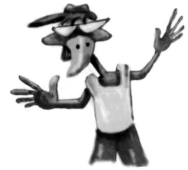

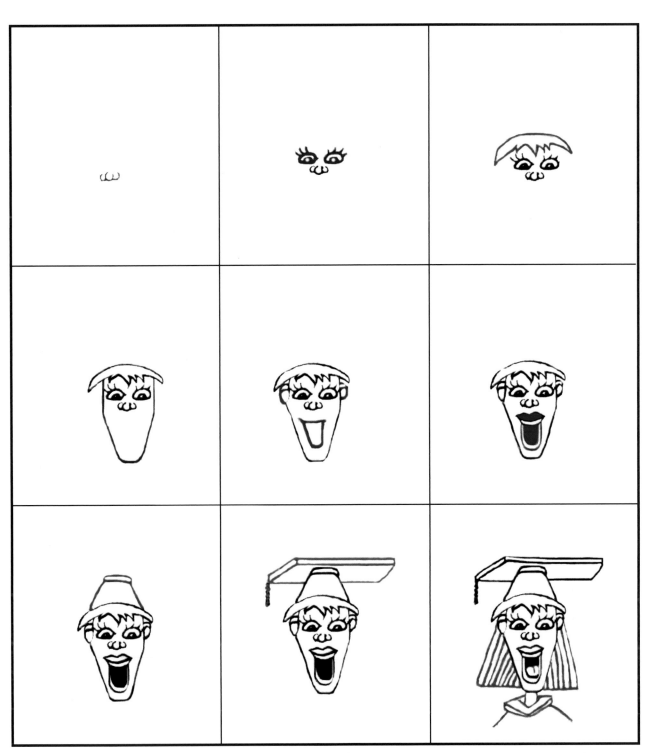

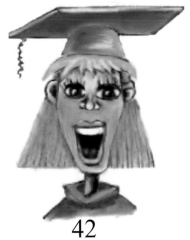

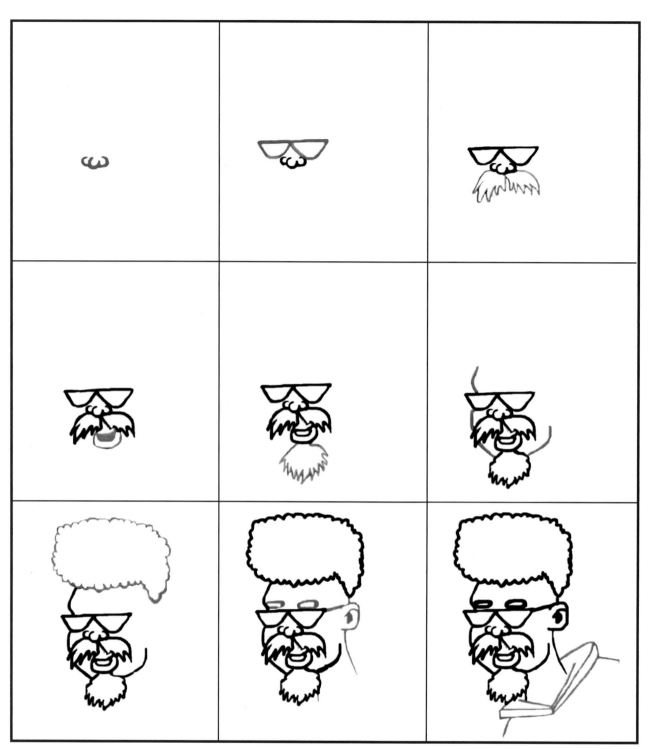

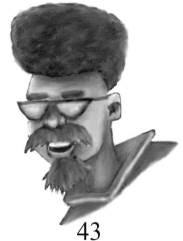

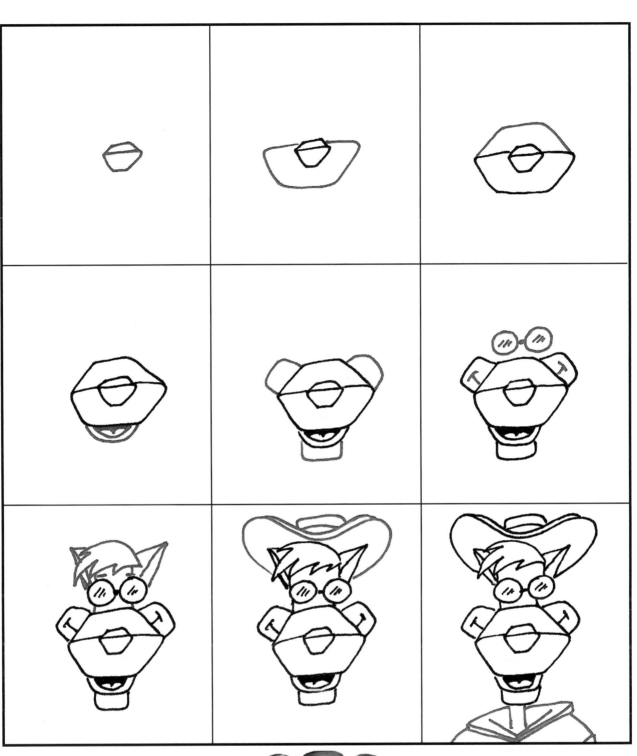

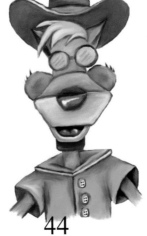

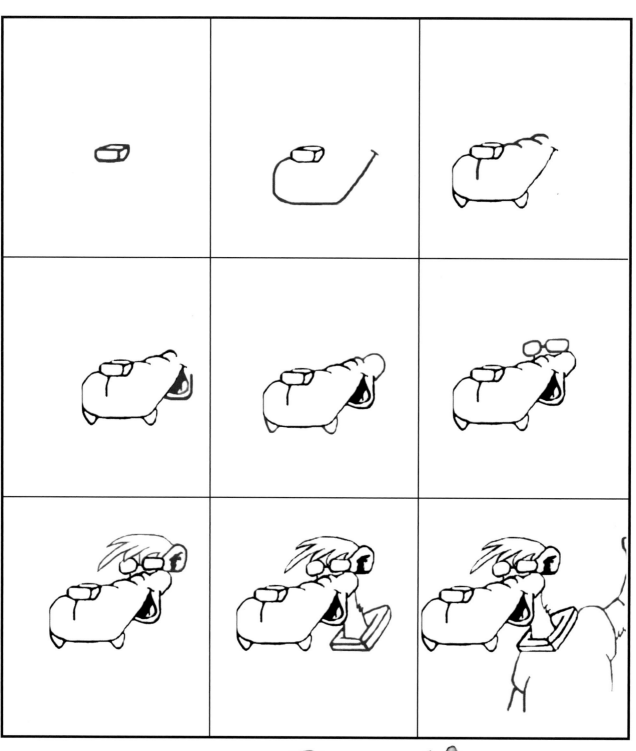

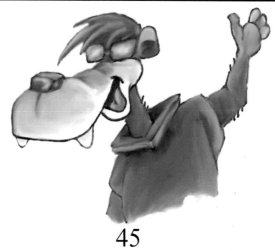

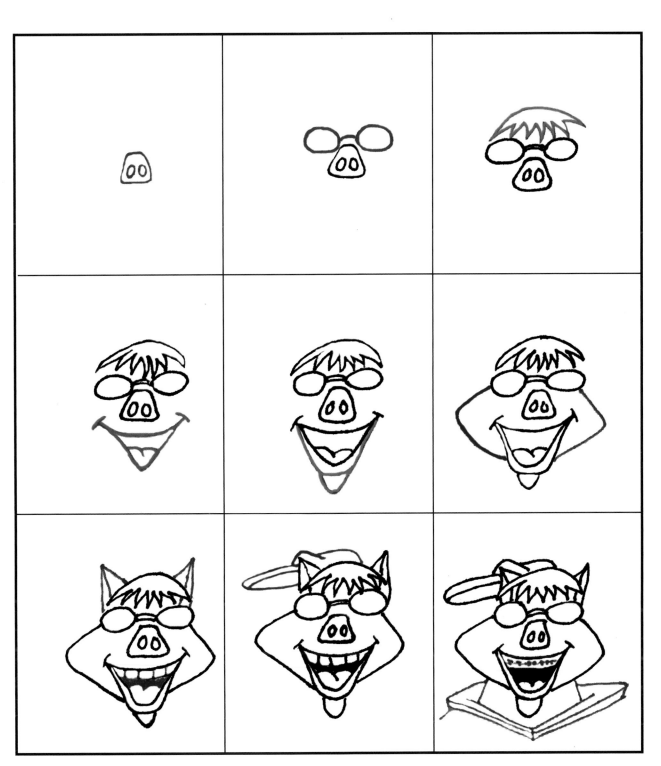

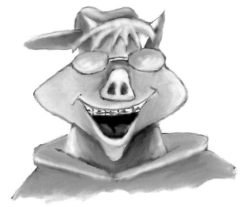

46

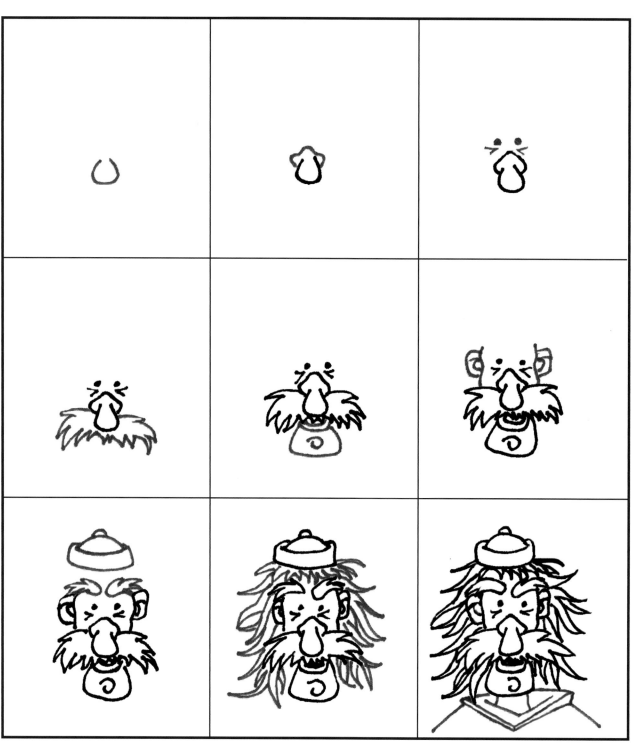
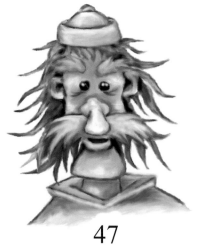

47

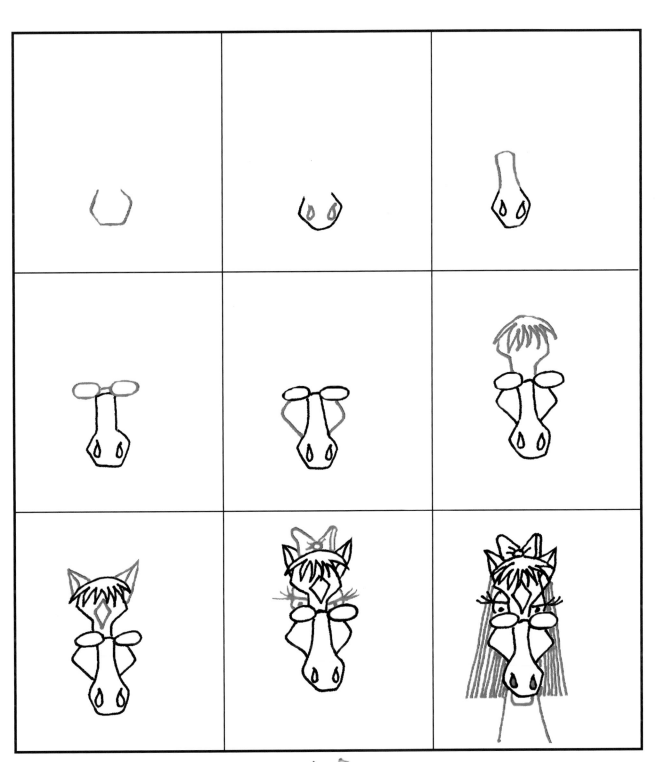

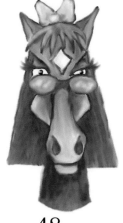

48

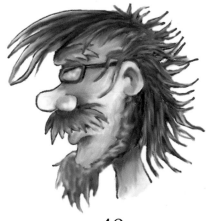

49

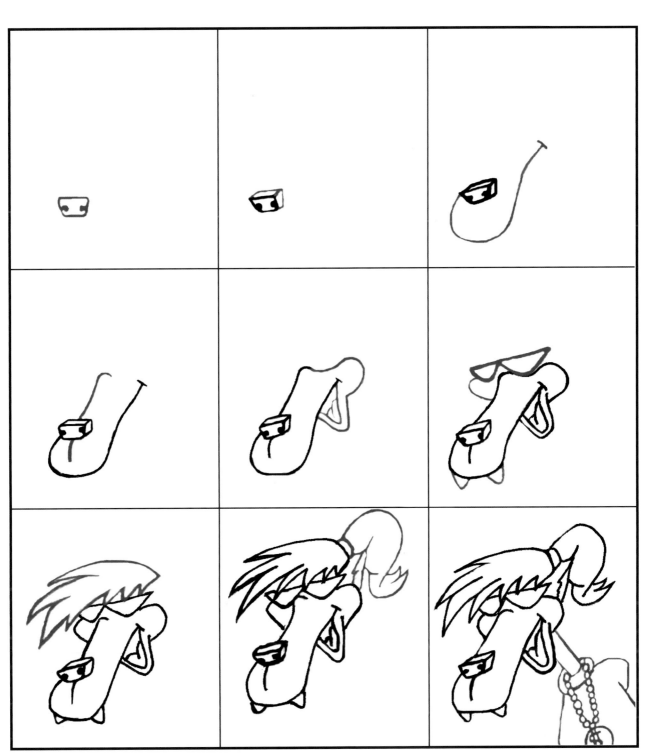

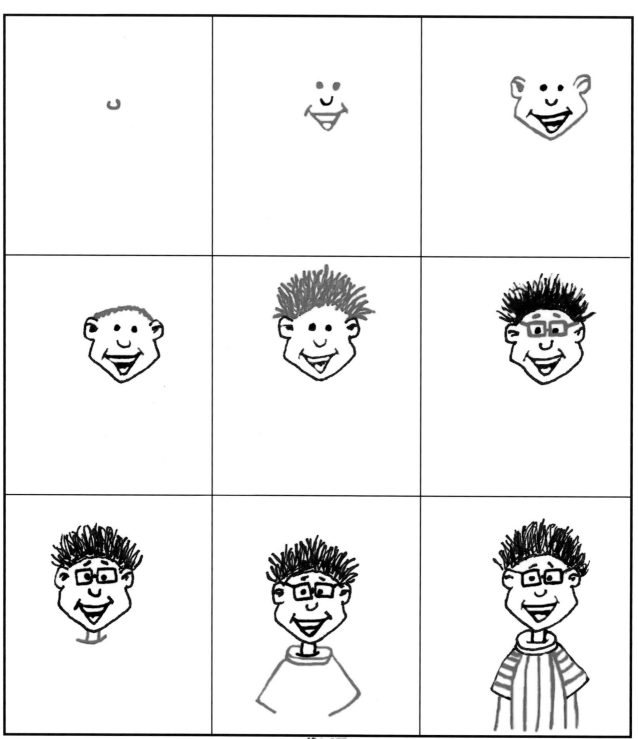

51

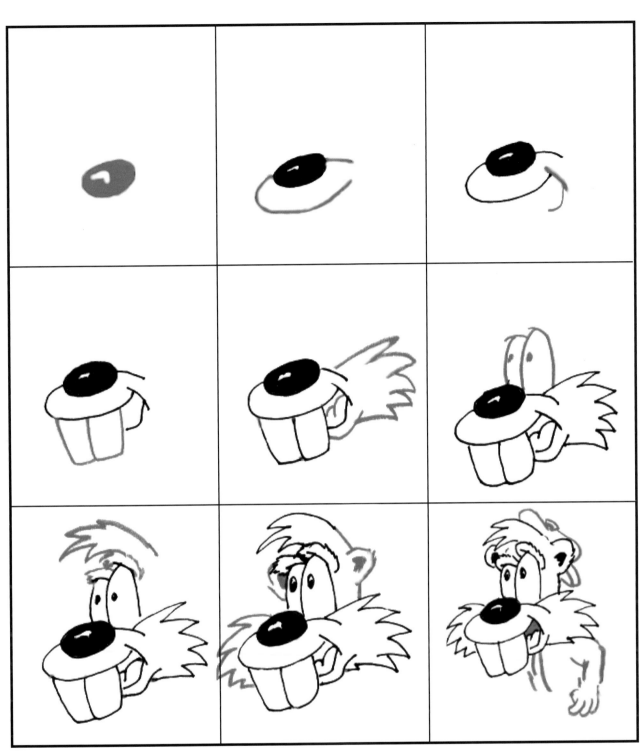

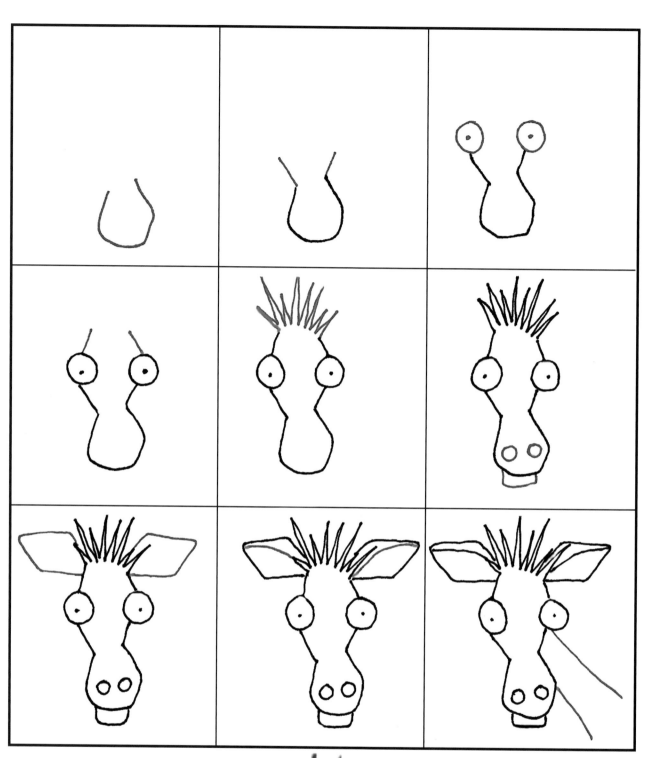

53

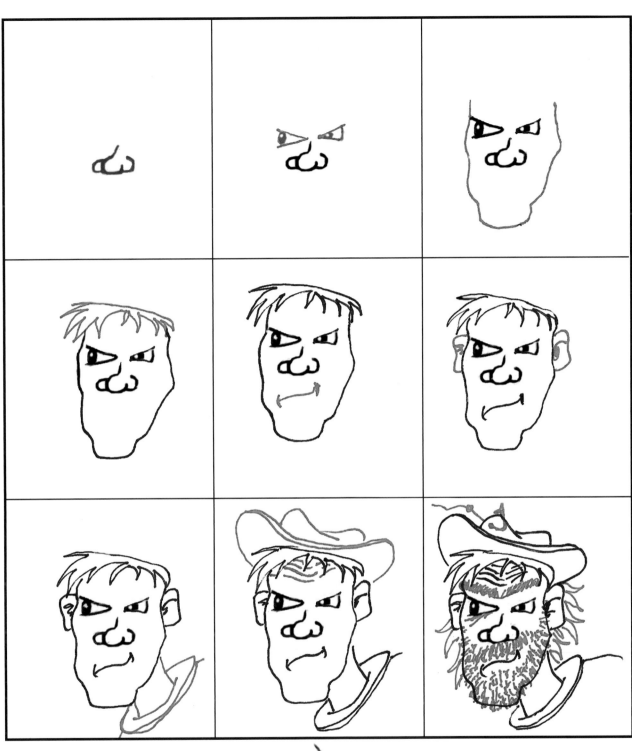

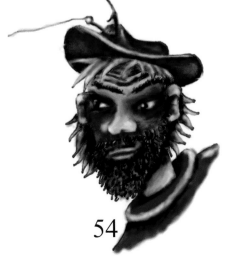

54

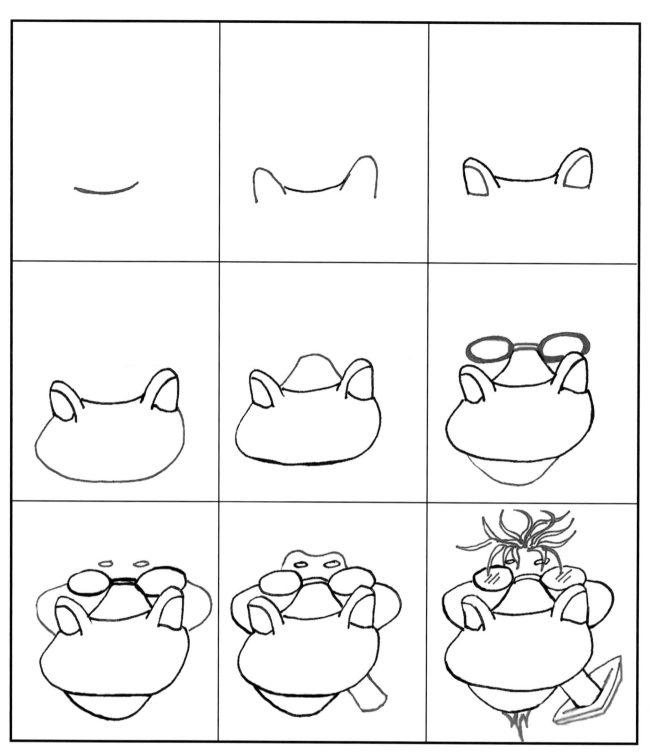

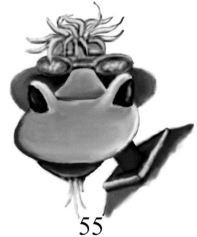

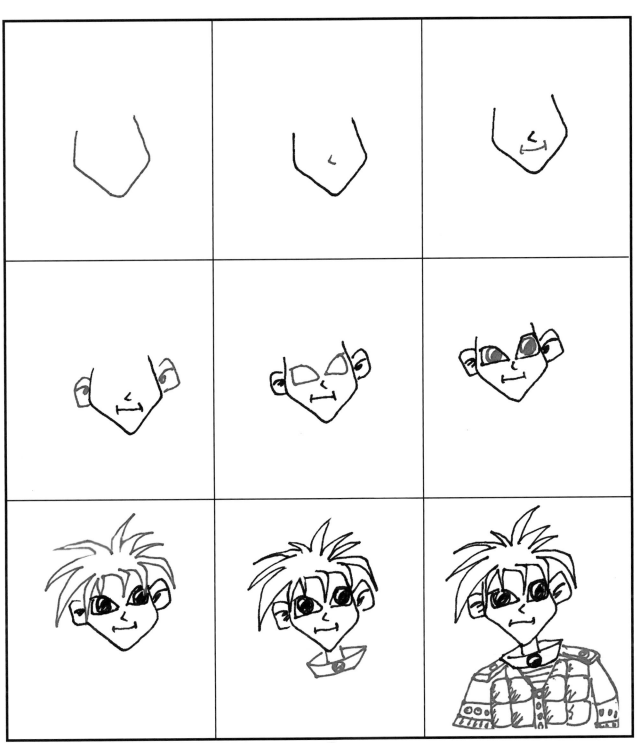

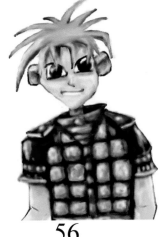

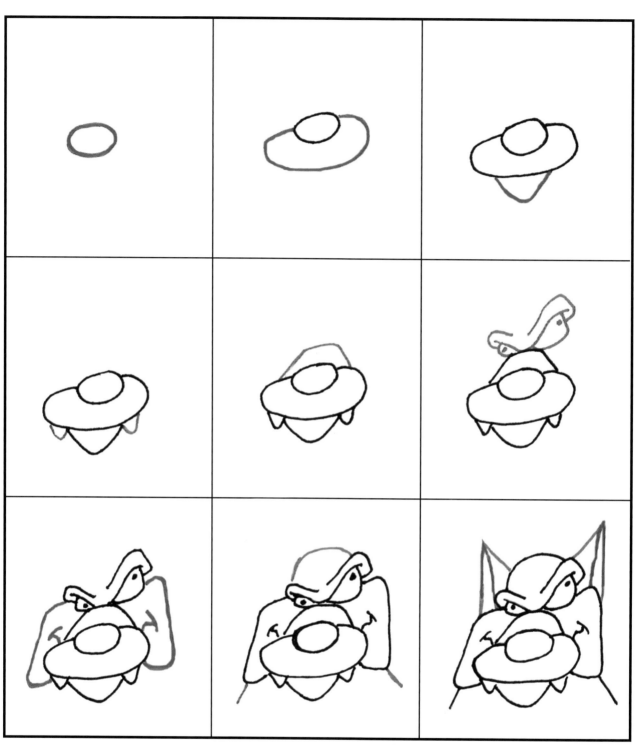

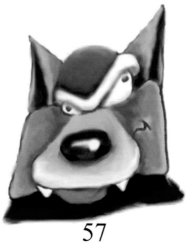

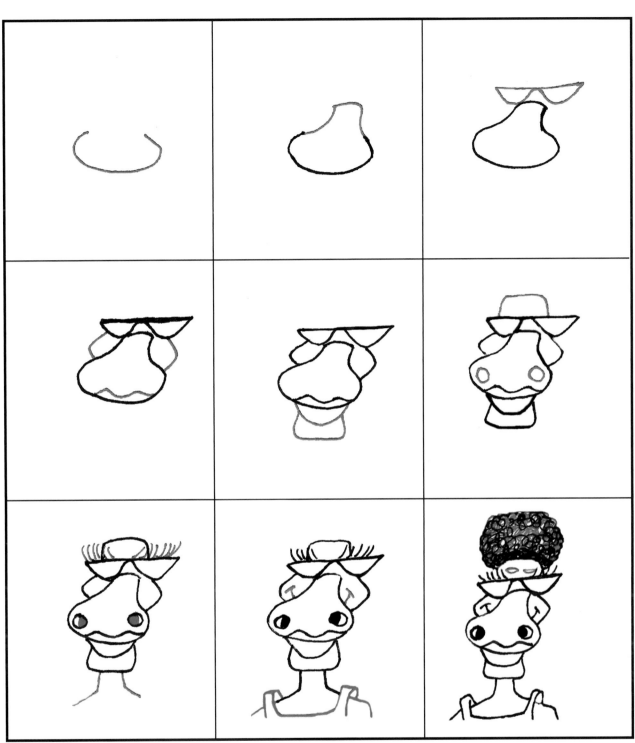

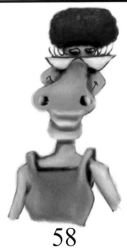

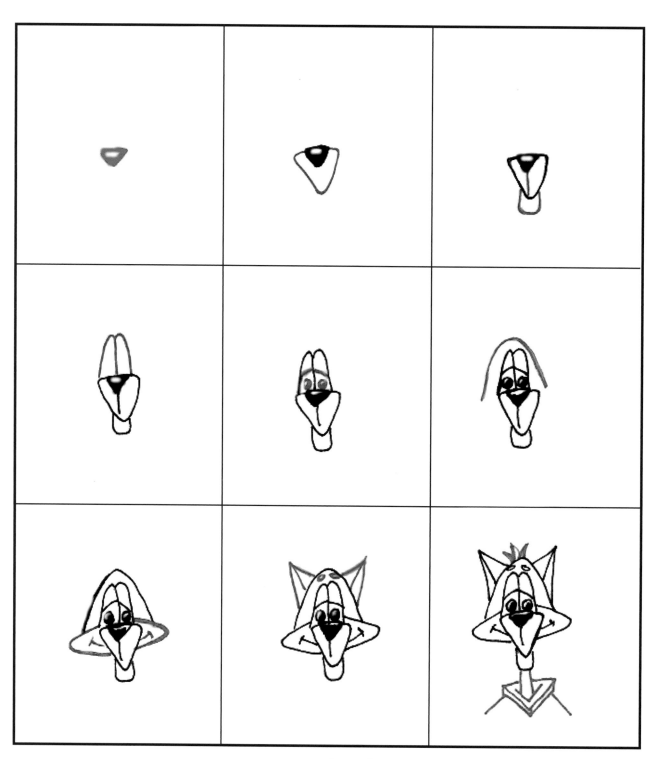

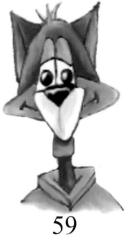

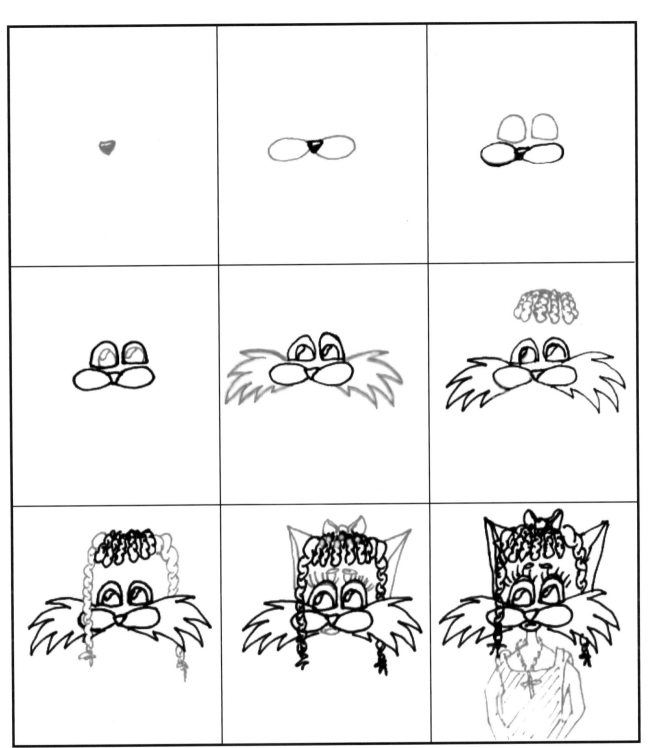

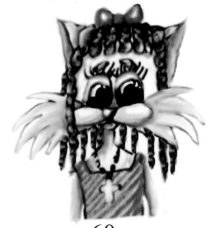

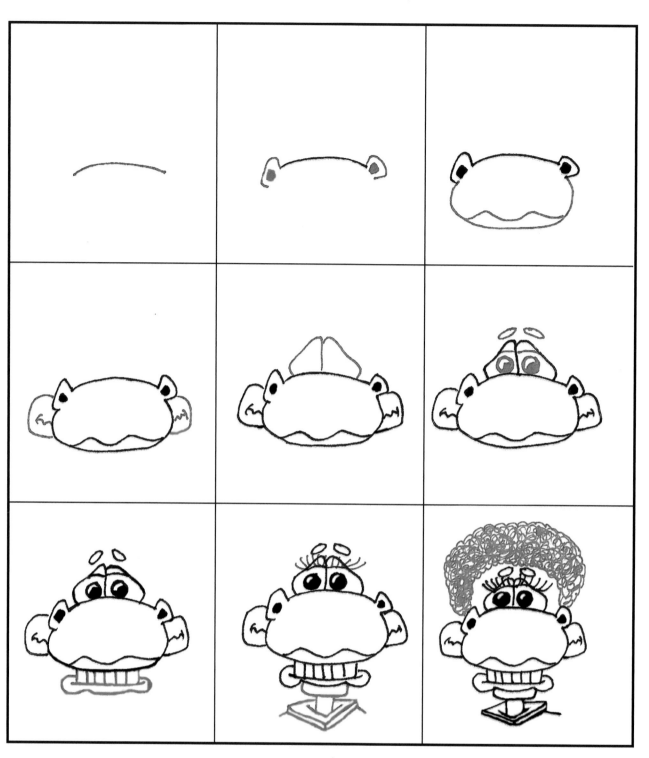

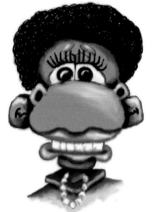

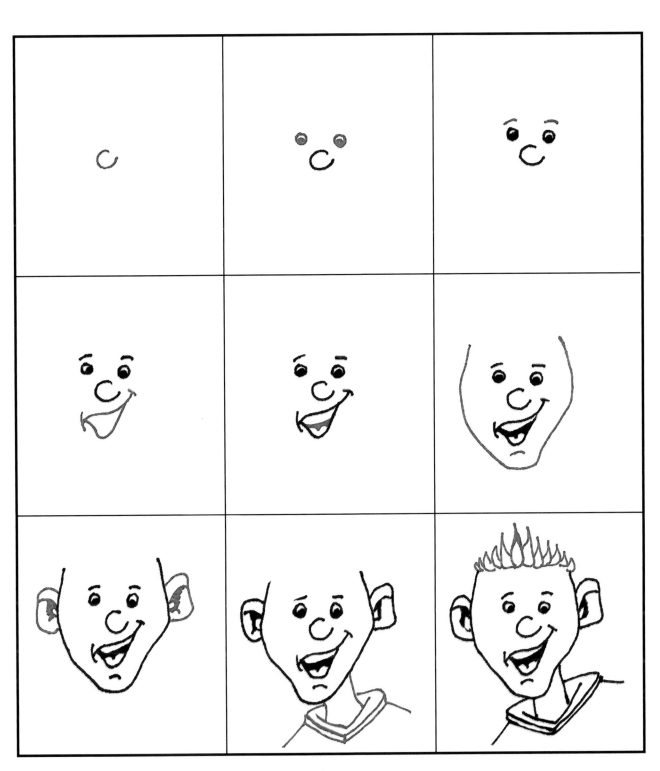

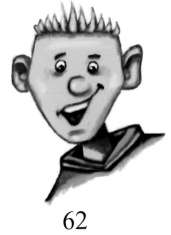

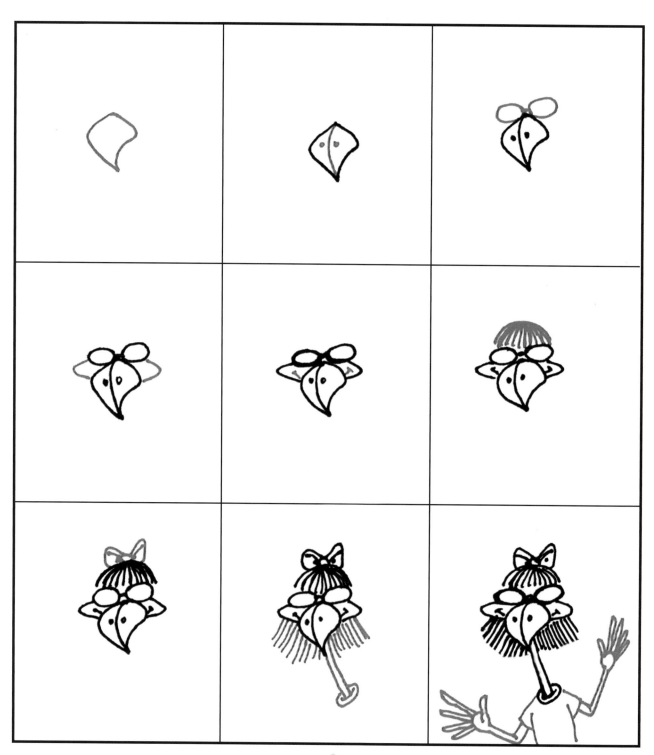

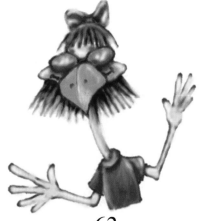

63

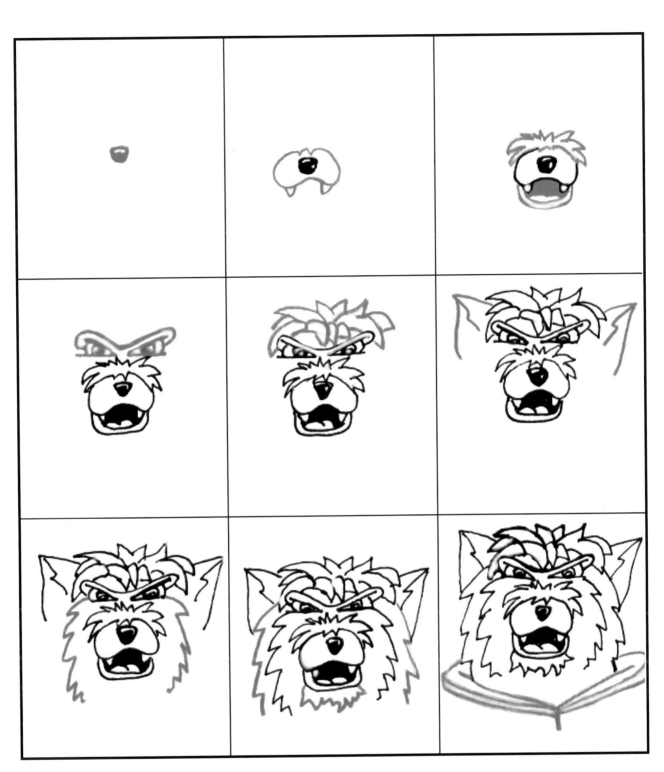

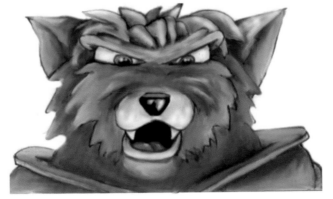

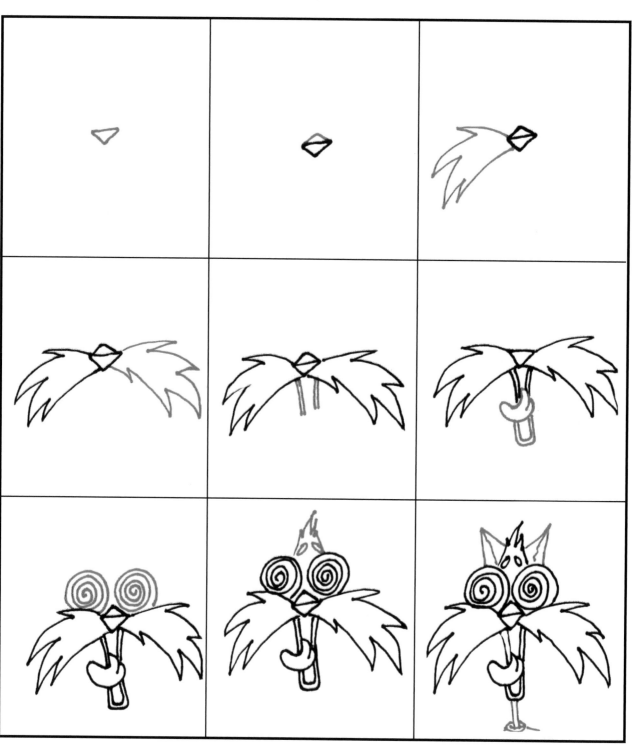

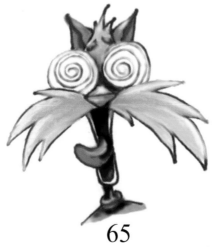

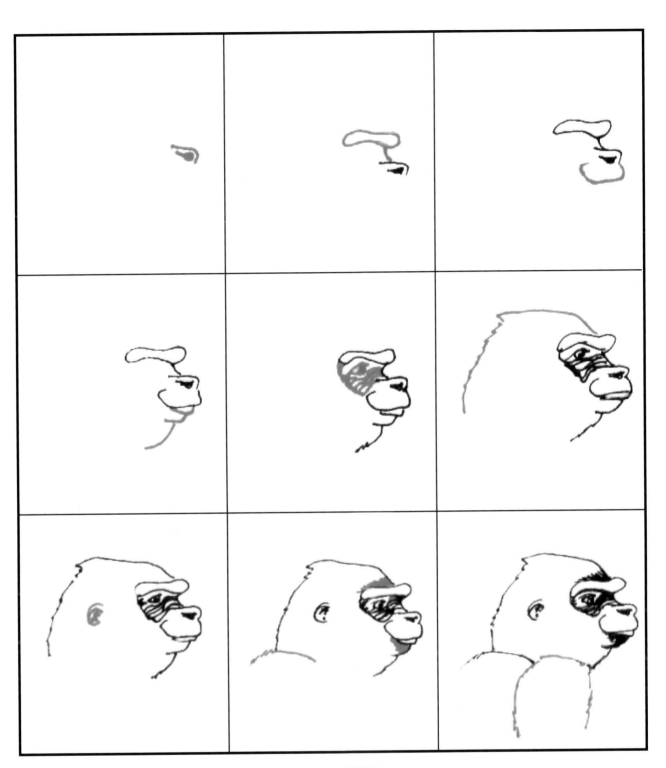

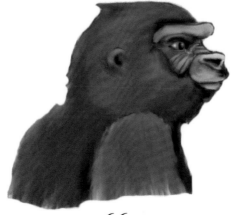

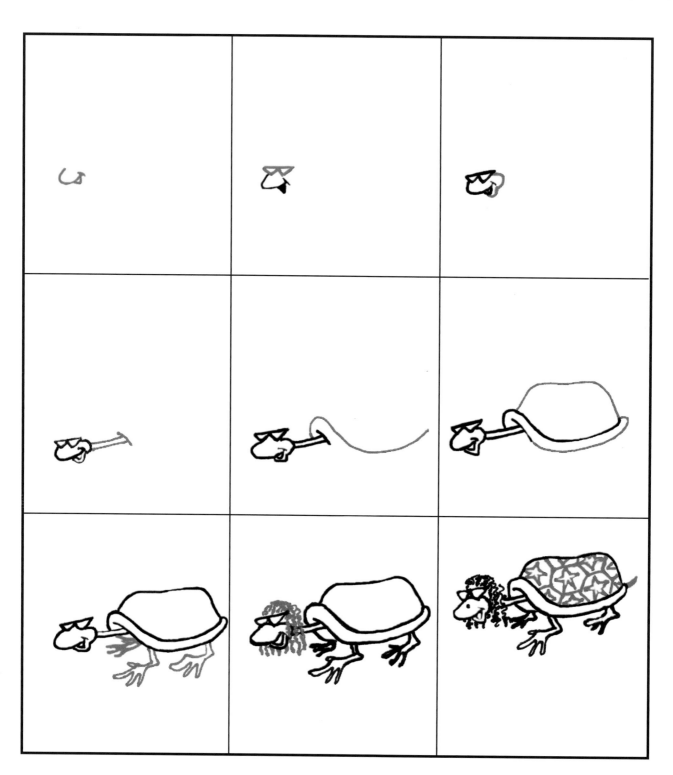

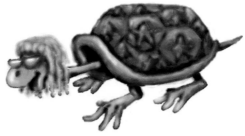

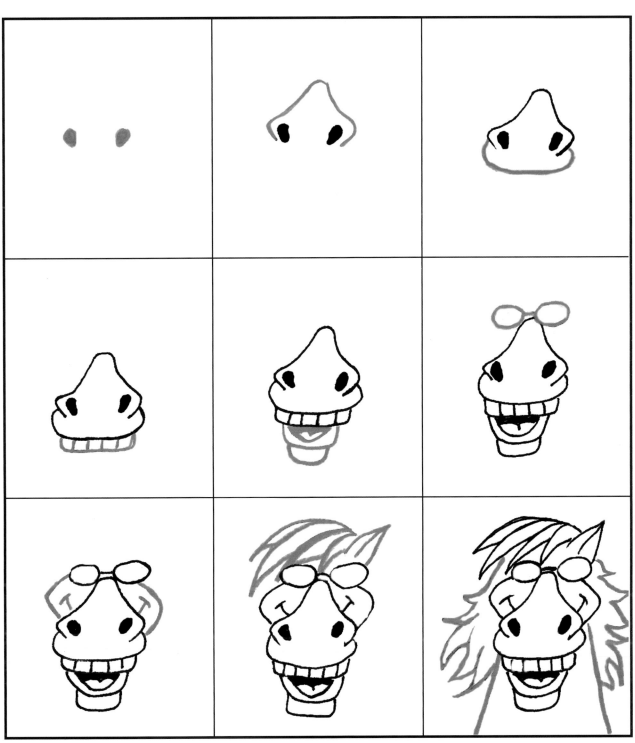

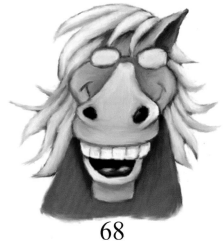

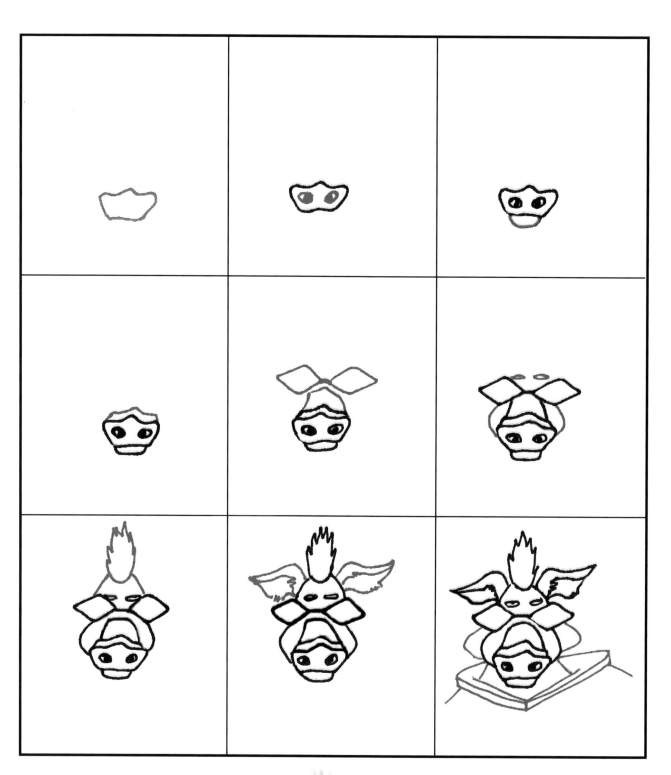

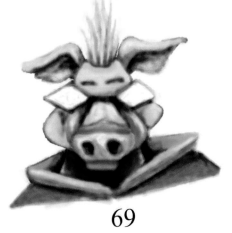

69

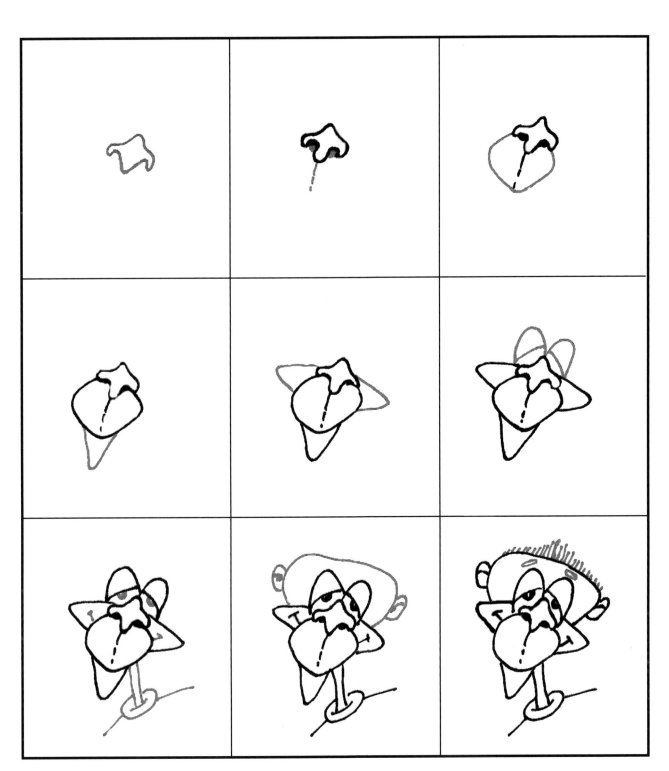

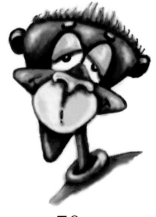

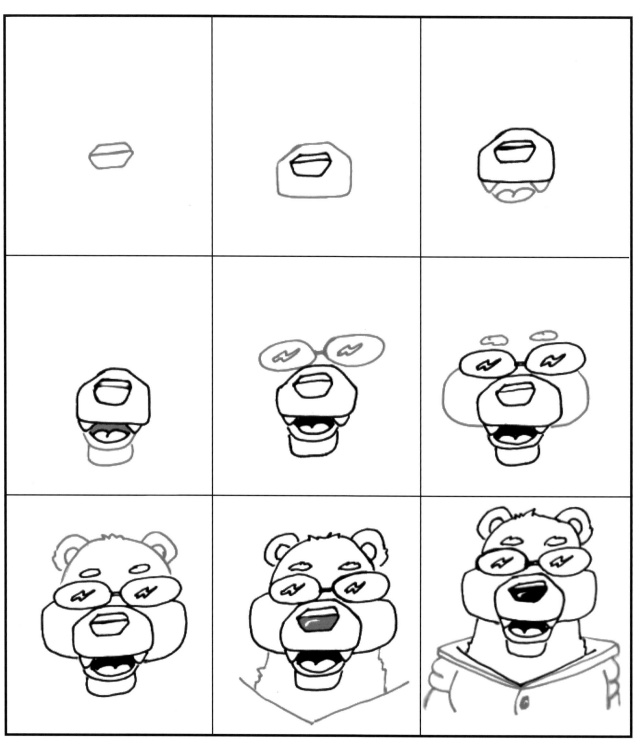

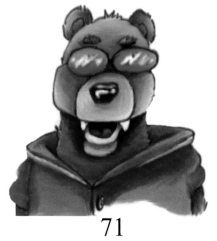

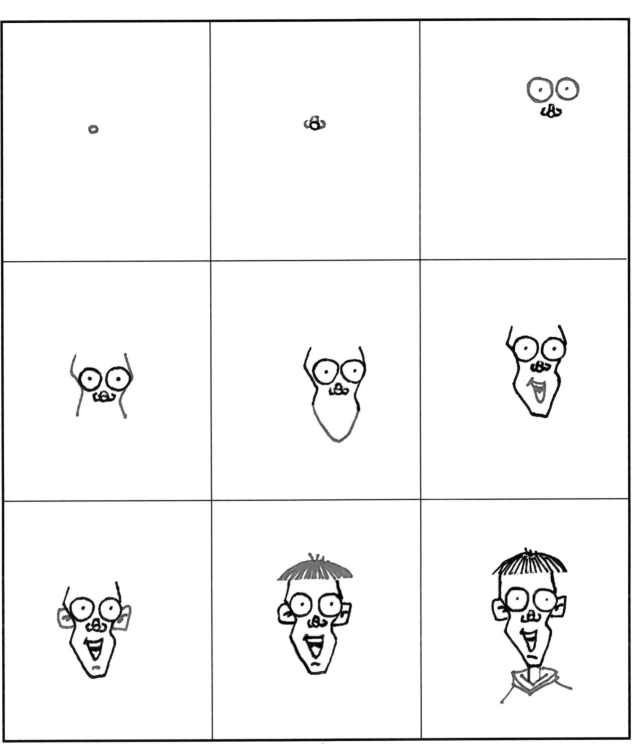

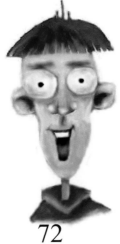

72

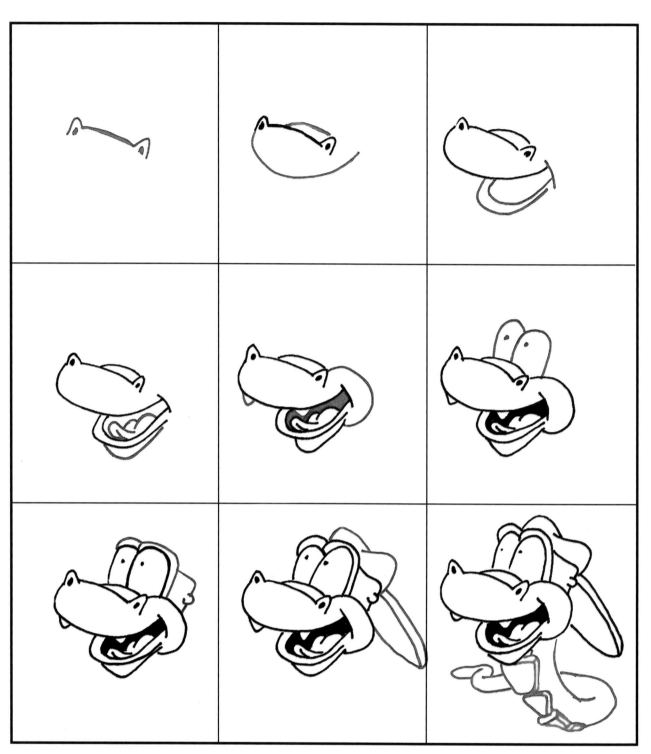

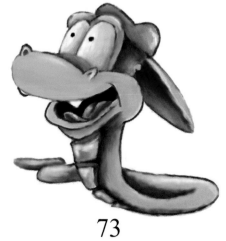

73

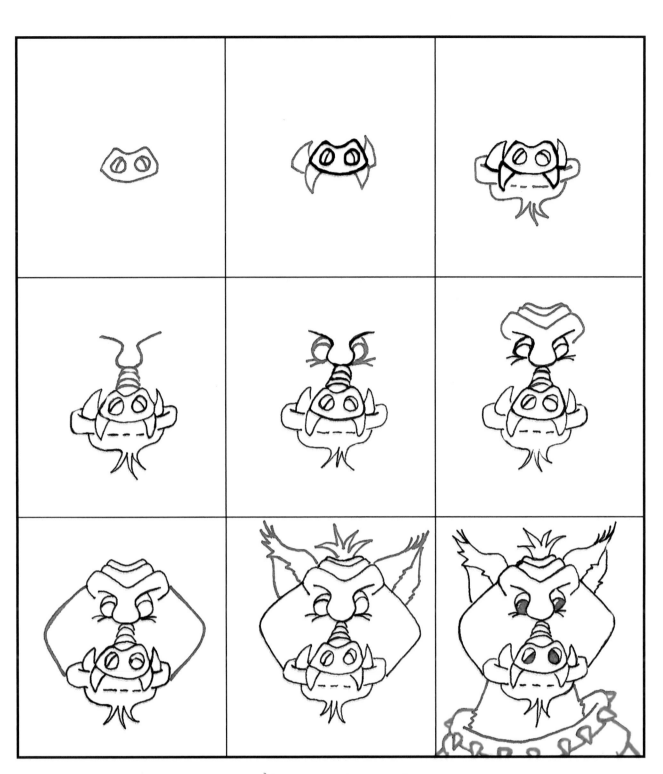

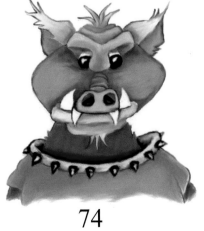

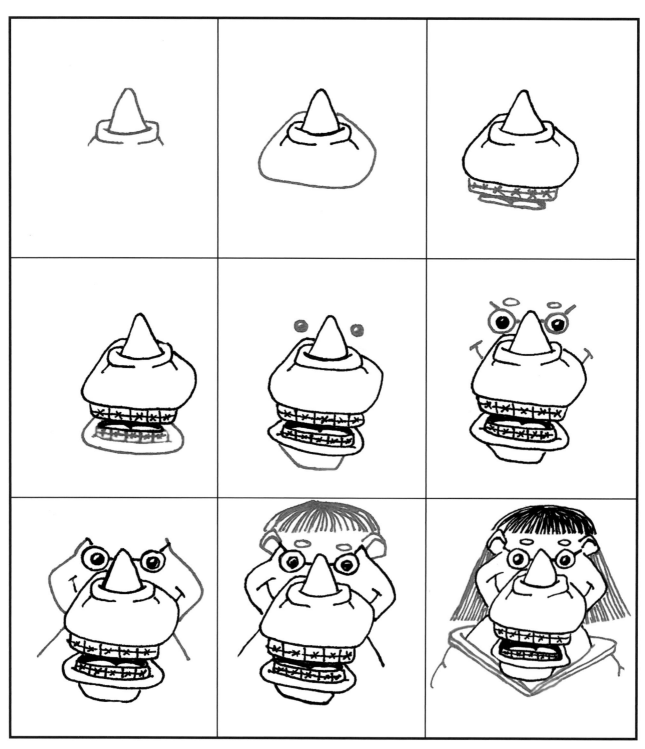

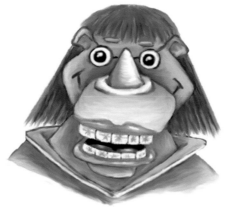

75

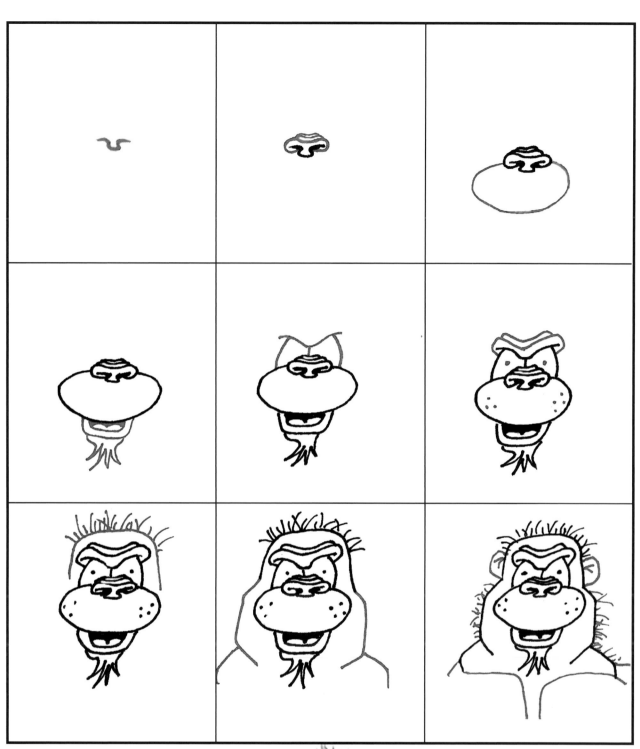

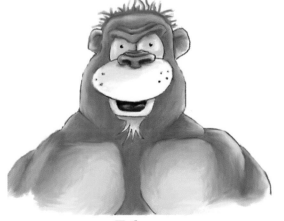

76

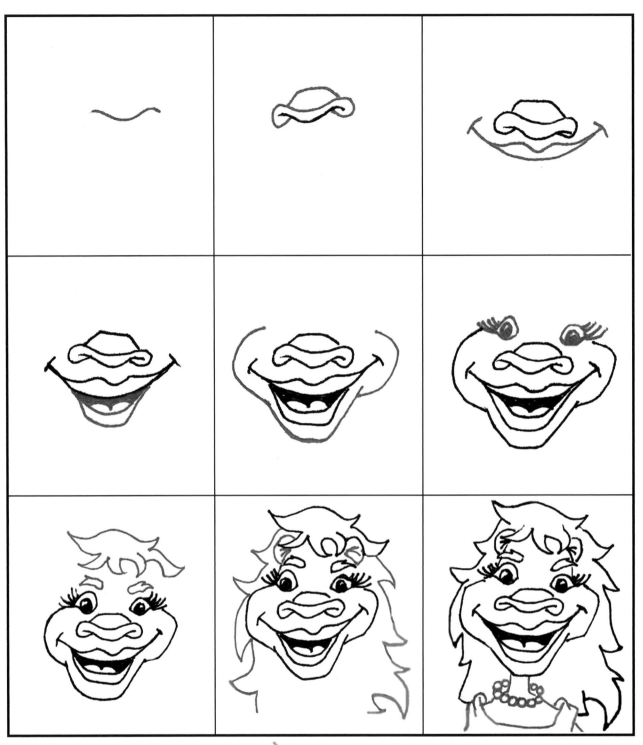

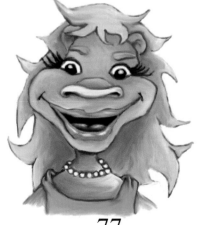

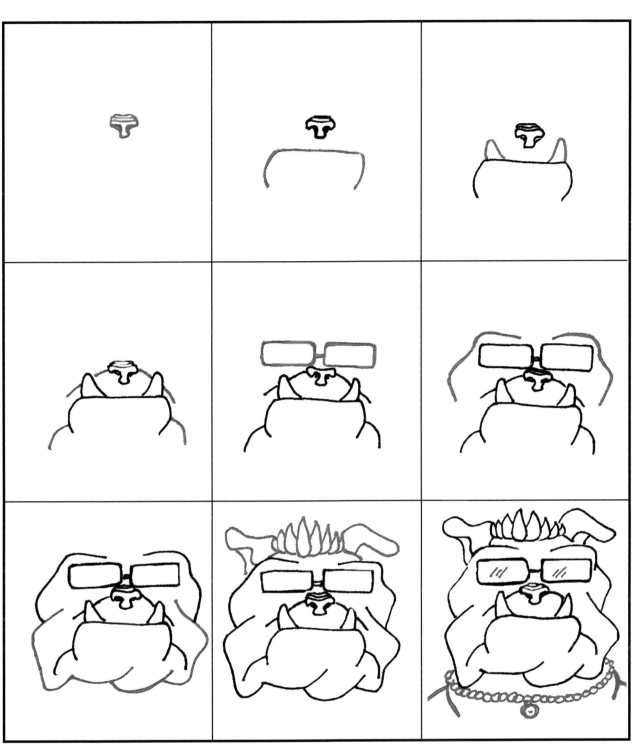

78

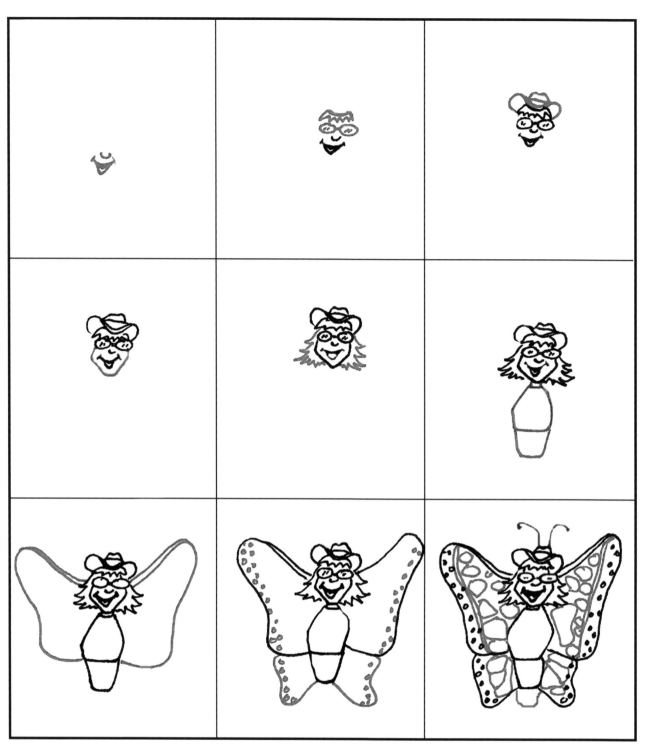

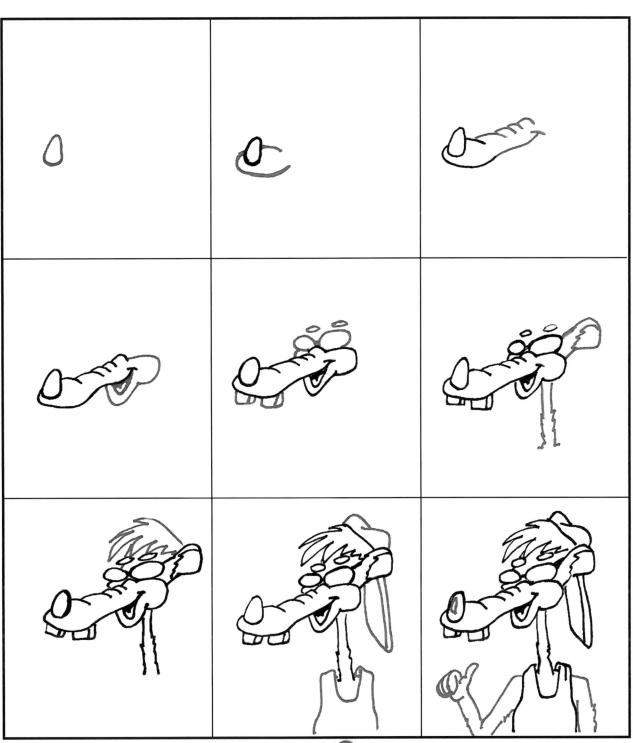

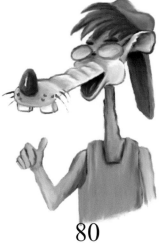

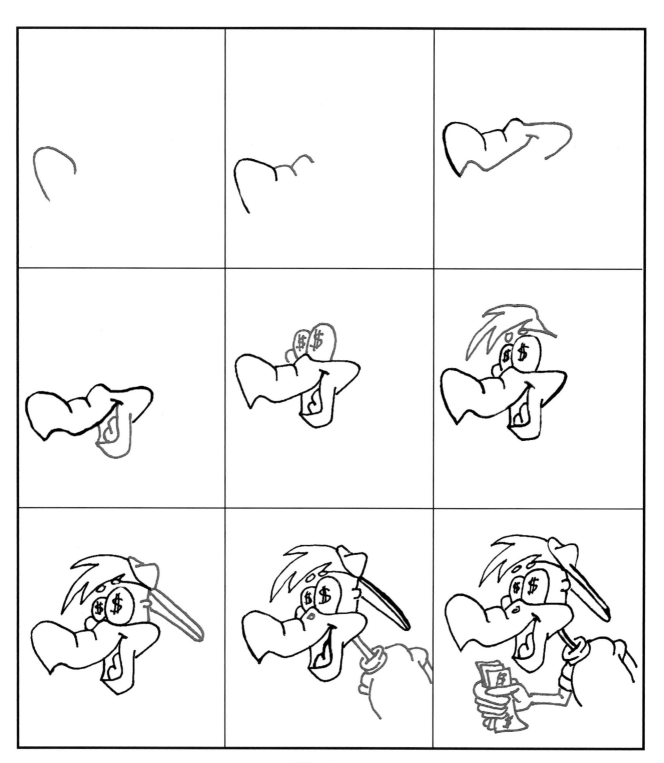

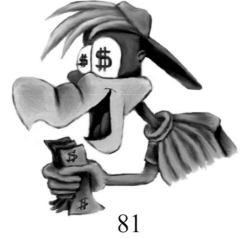

81

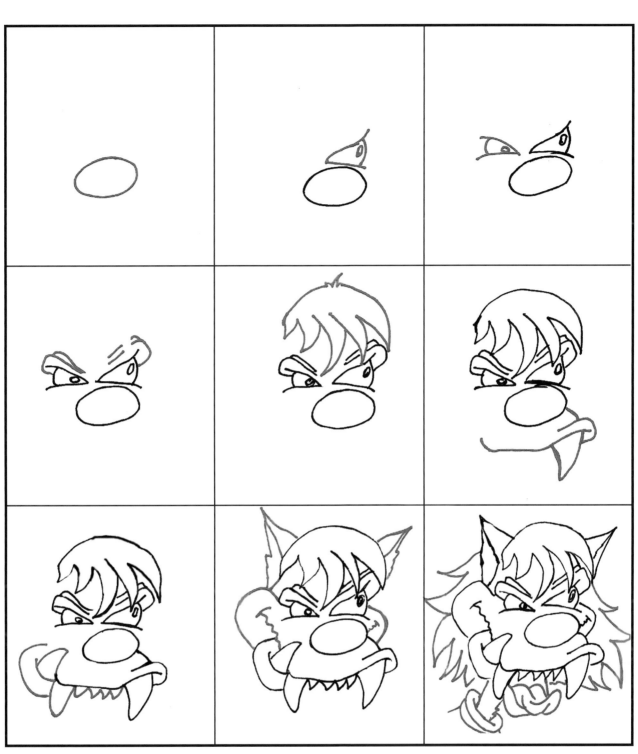

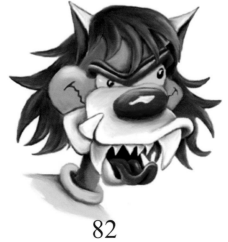

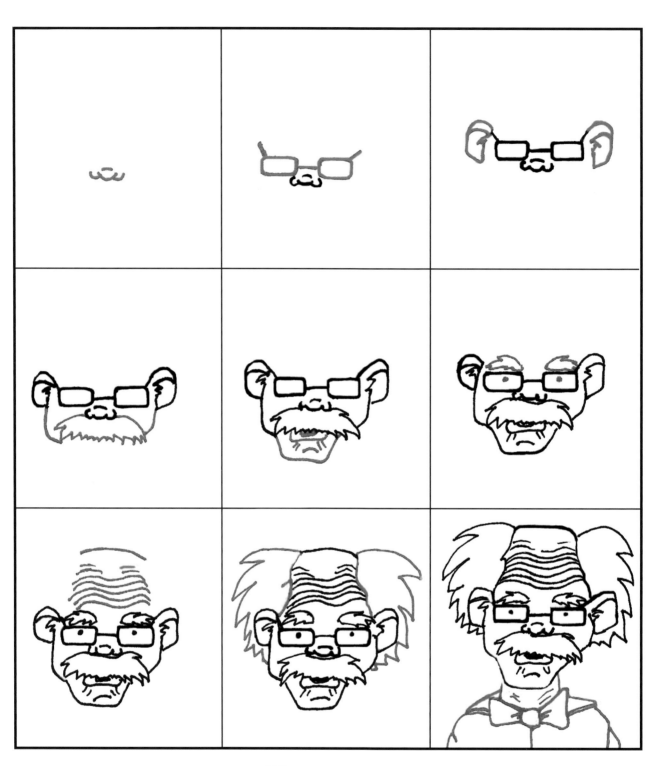

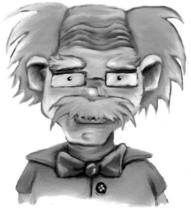

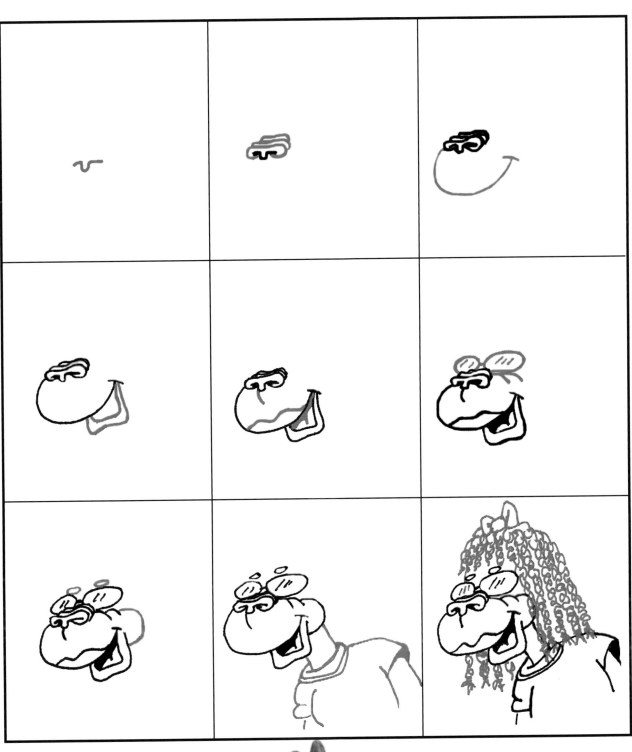

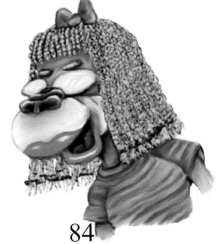

84

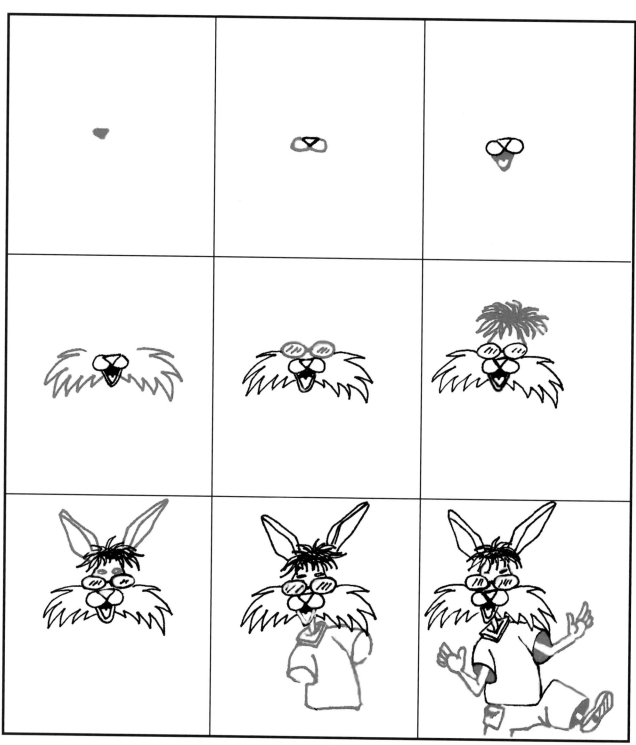

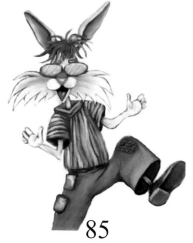

85

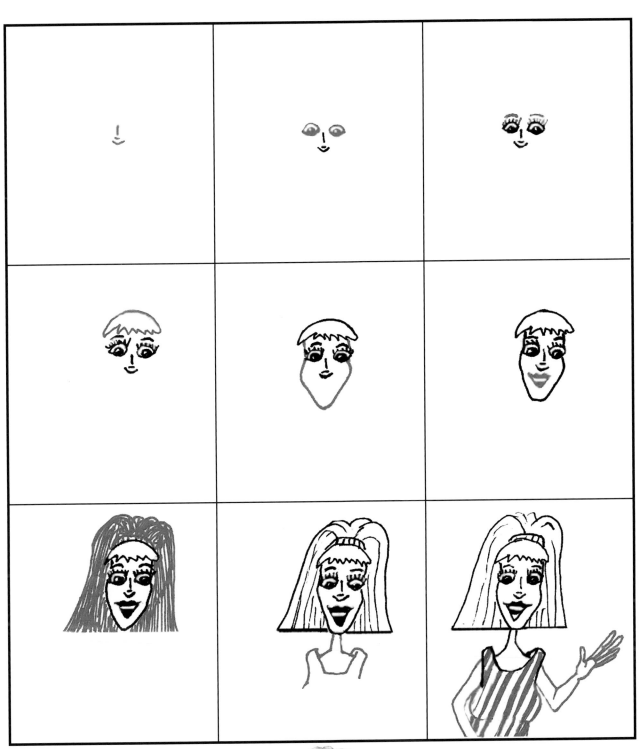

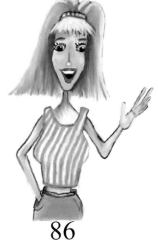

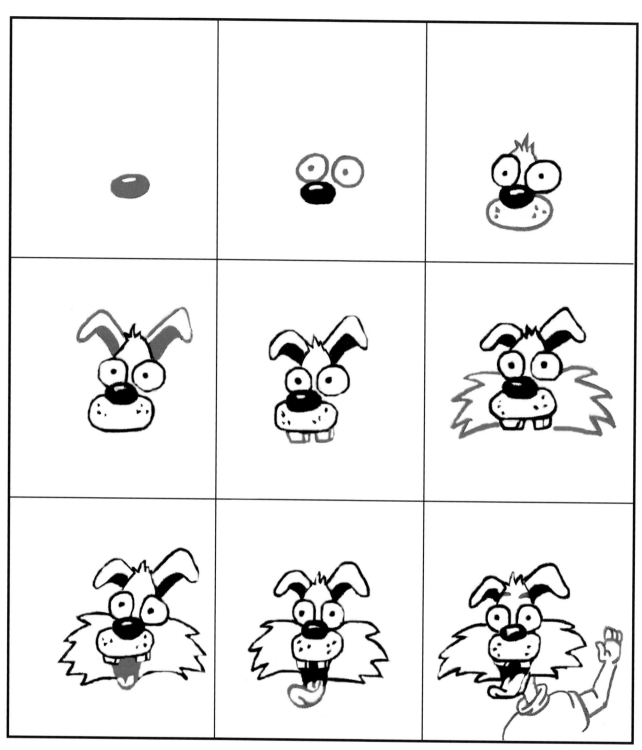

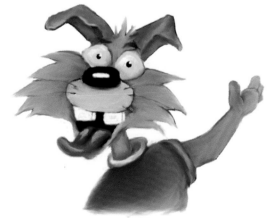

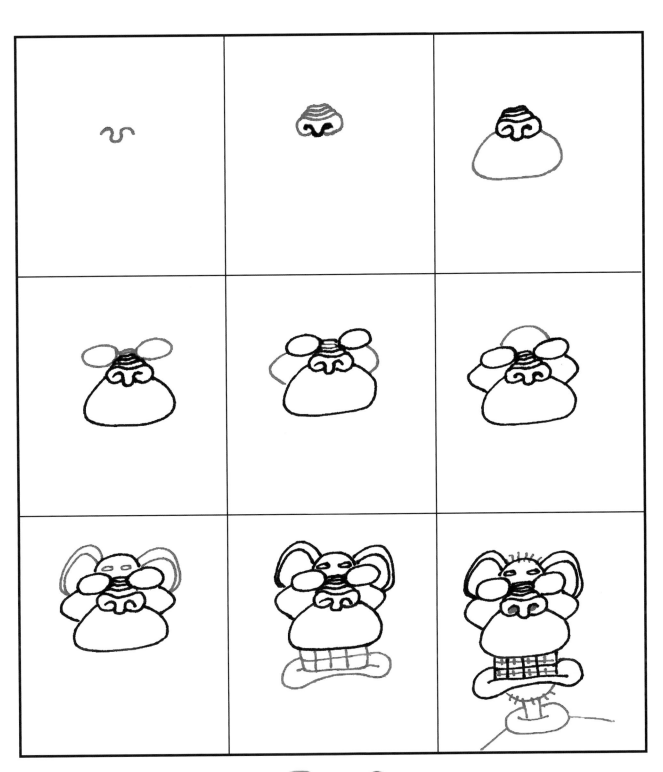

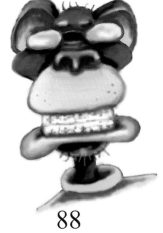

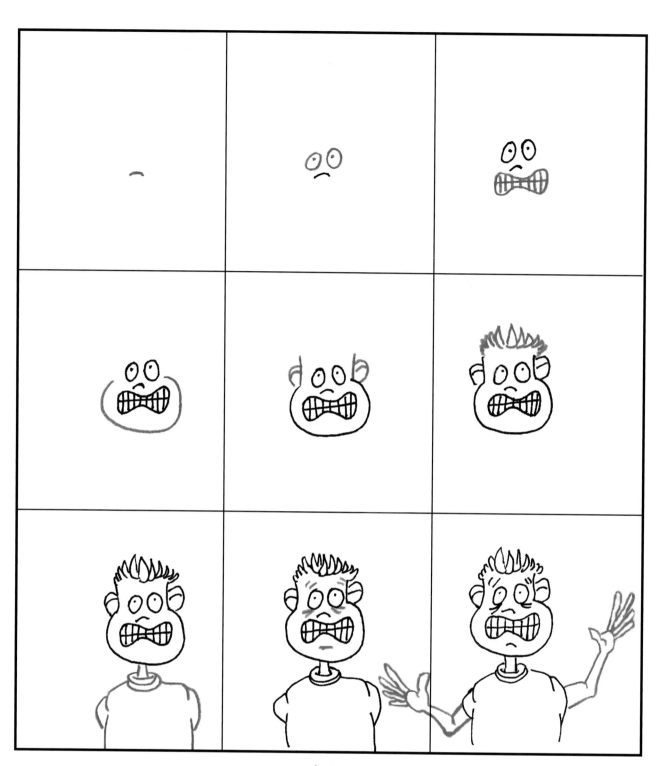

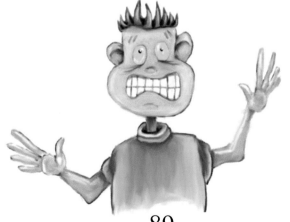

89

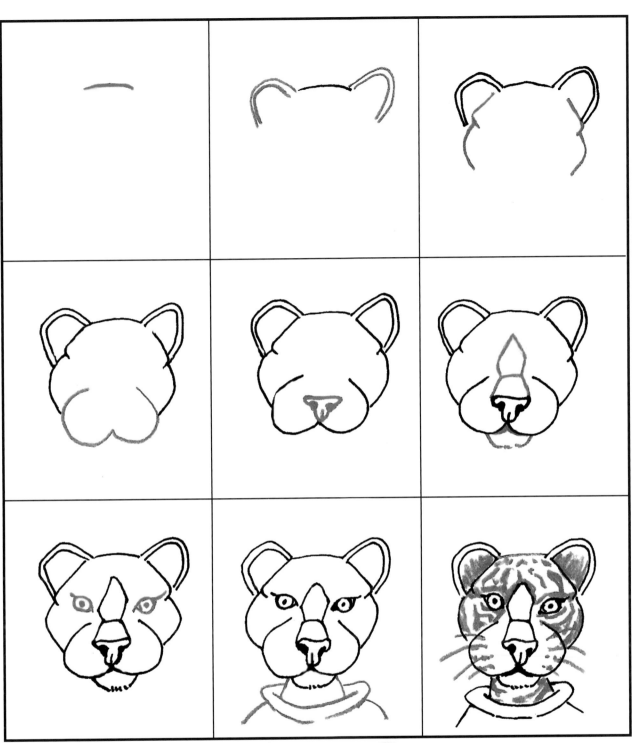

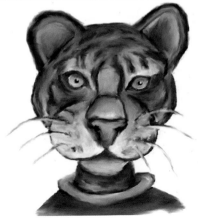

90

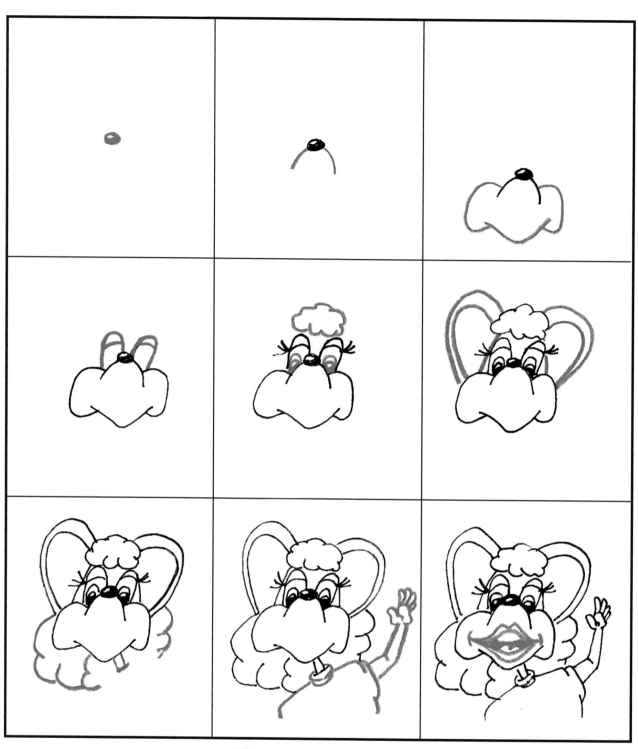

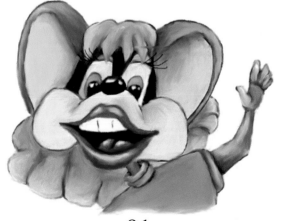

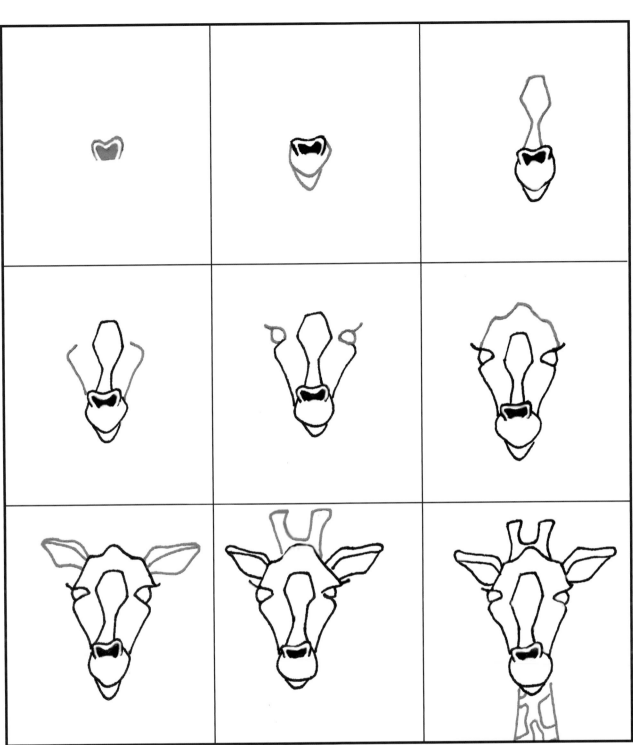

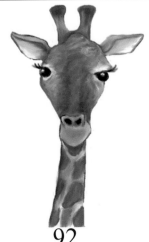

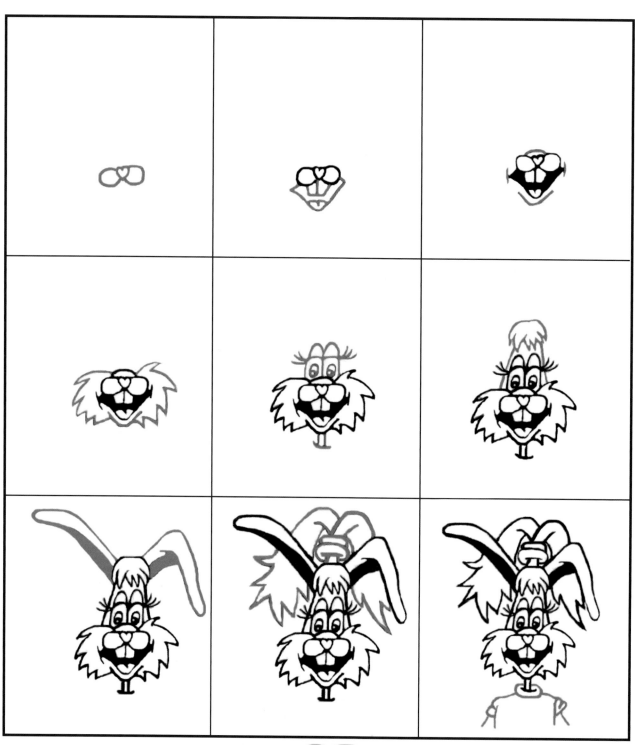

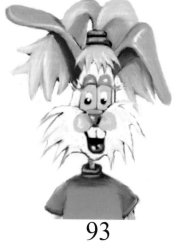

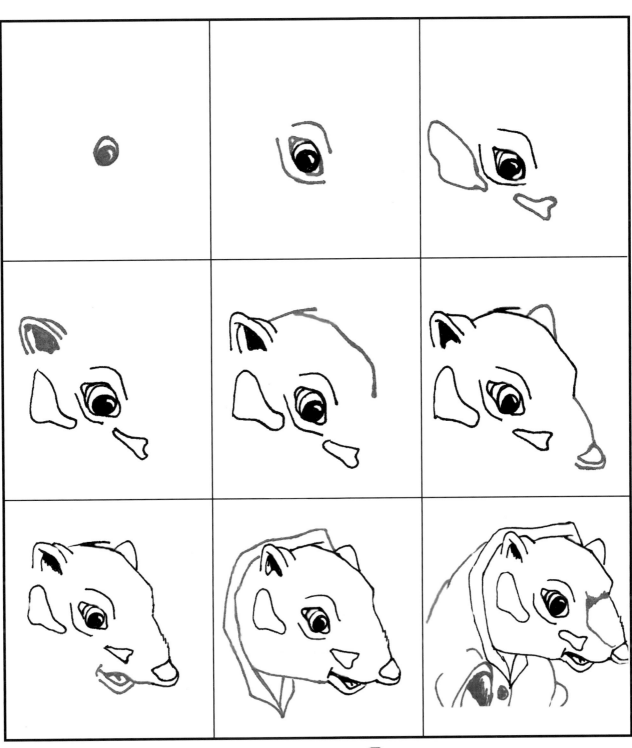

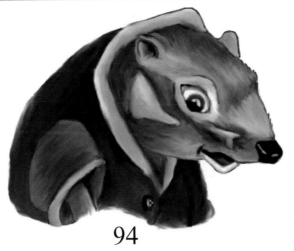

94

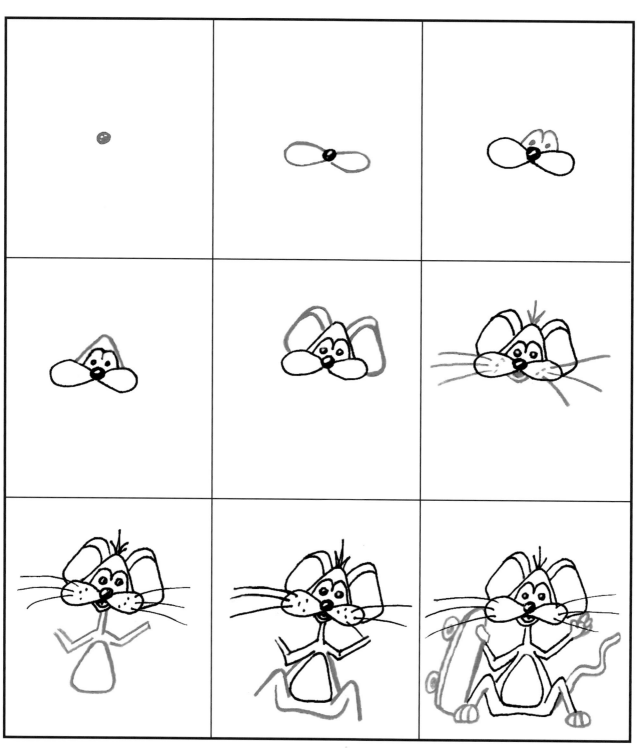

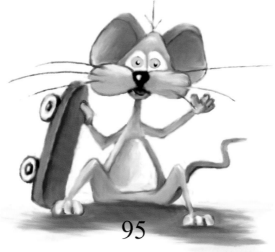

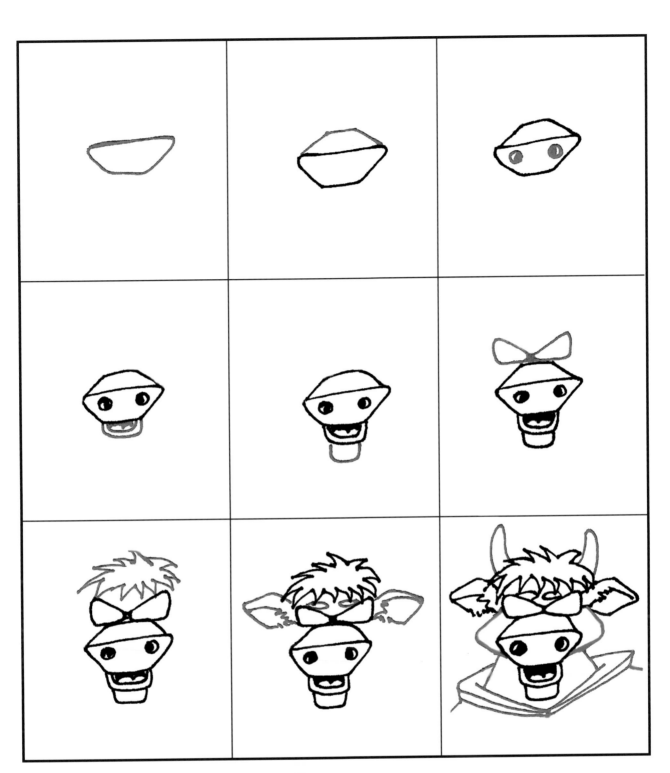

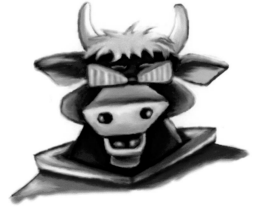

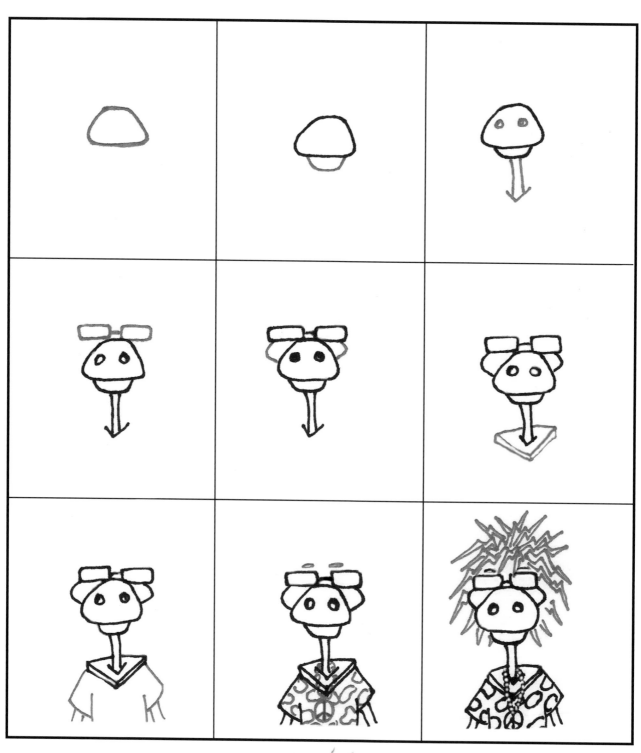

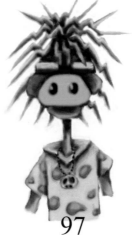

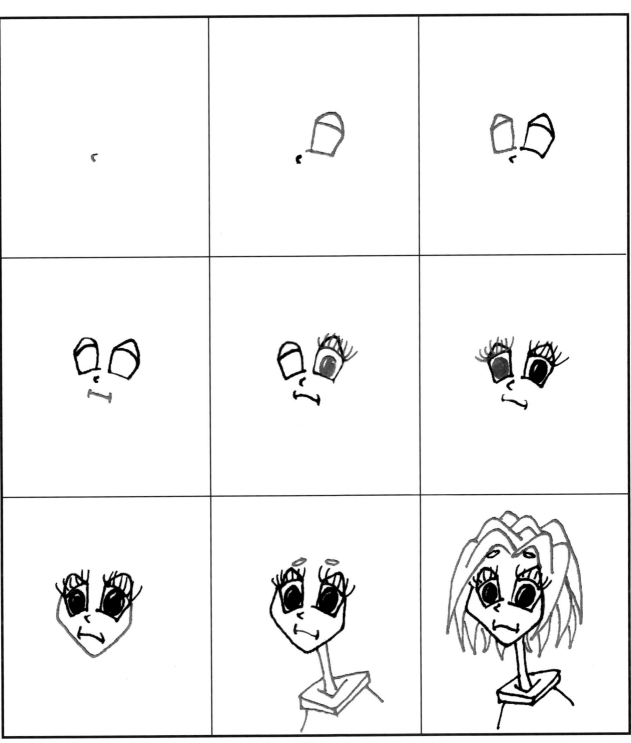

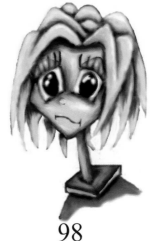

98

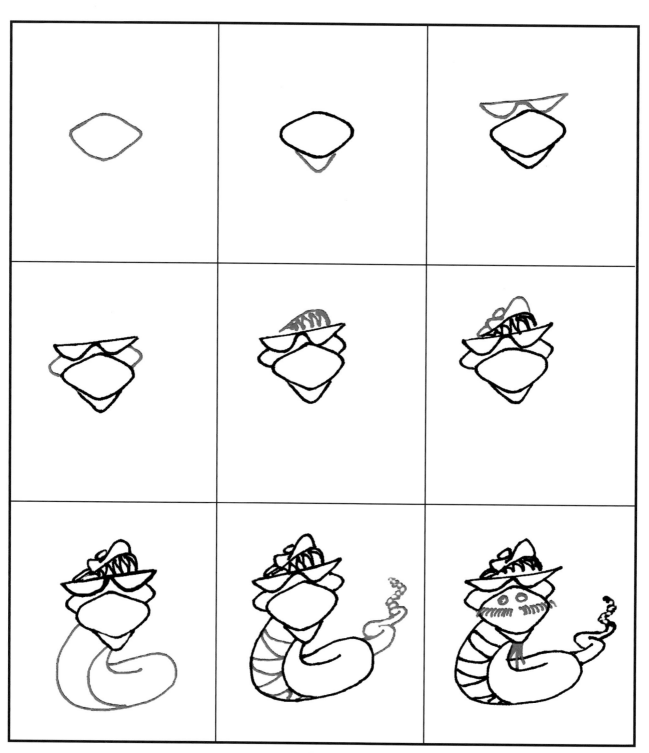

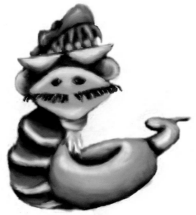

99

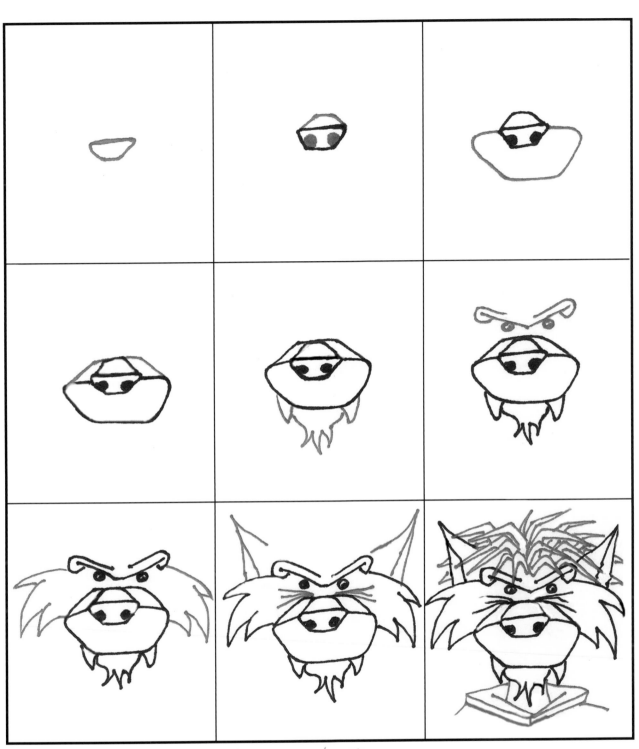

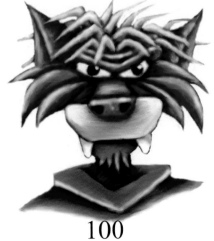

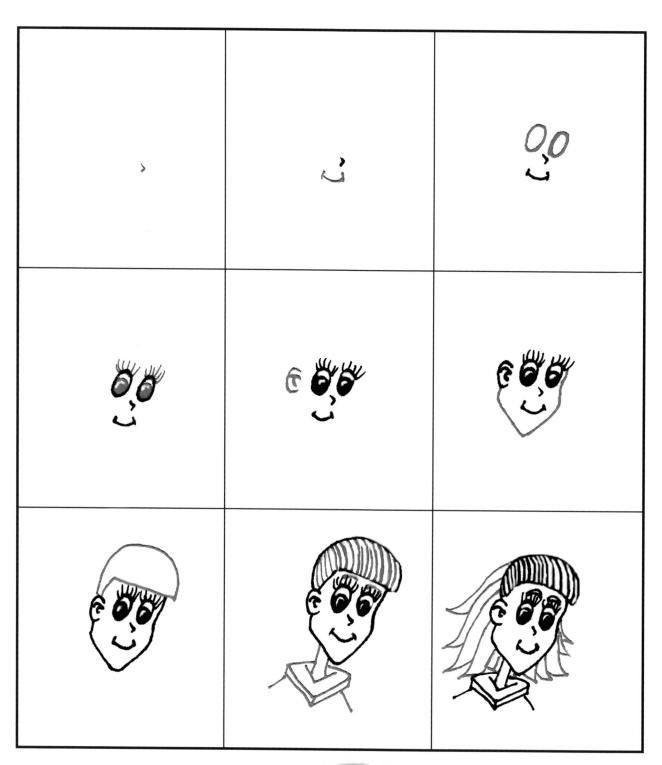

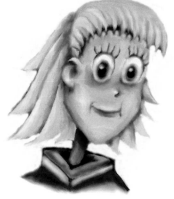

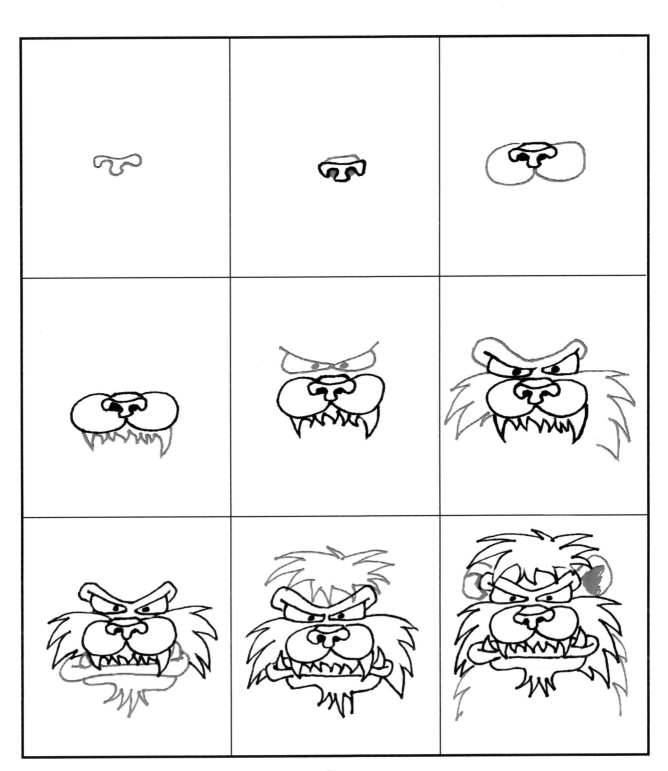

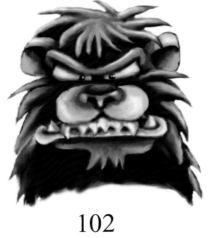

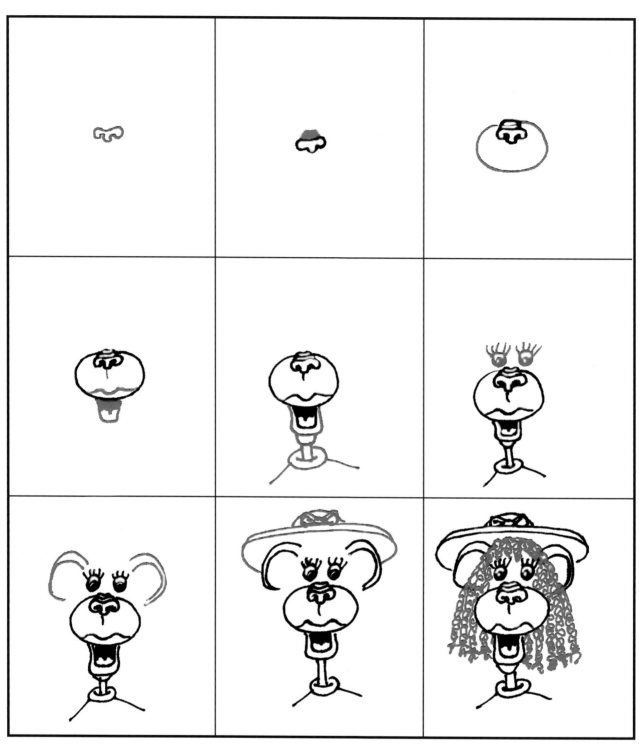

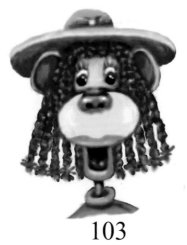

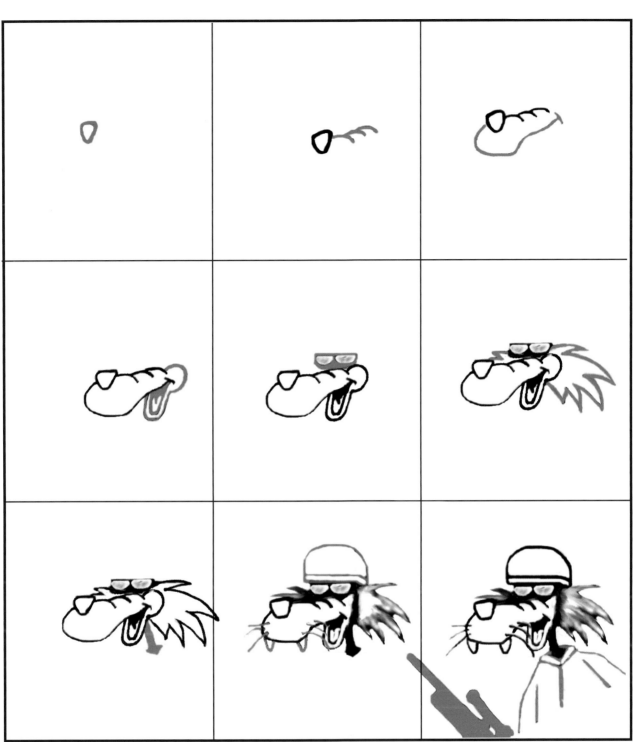

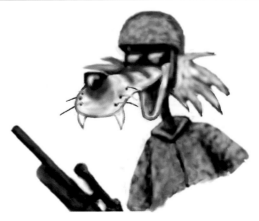

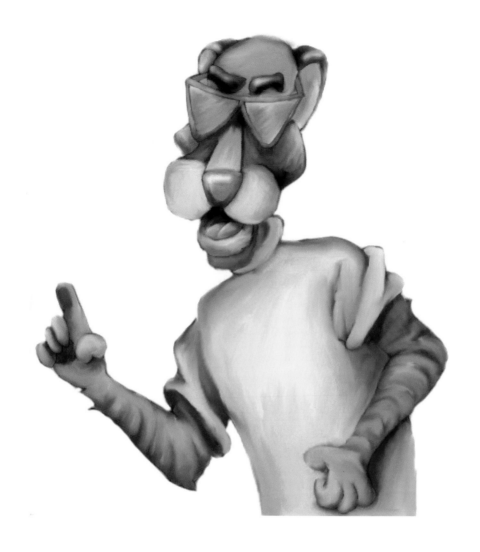

I hope that these lessons have been helpful to you and that you will be blessed to use your passion for art somewhere in the future...

your friend,

Gary Harbo

Artist-in-residence by Gary Harbo

For availability call: (651) 450-7427

What are teachers saying?

"In my 19 years of experience in education, I have never observed a more child-centered program for children. The students were so mesmerized and motivated to draw. It was truly a rewarding experience." (Springfield Elementary, Springfield MN)

"To quote a second grade teacher, "This was the best assembly we've ever had!" I have gotten tremendously positive feedback from students, teachers and parents. Thank you! (Liberty Elementary School, Fresno CA)

"Gary was fantastic! He showed great patience with the children and kept them engaged. They loved it!!!!" (Pleasant Lane Elementary, Lombard IL)

"This was an incredible presentation!" (Lake Superior Elementary, Superior WI)

"Very exciting! Gary's worth the money and time!" (John Nowlin Elem., Blue Springs MO)

"Wow!! Excellent - Gary kept my class motivated for an hour. They loved it. The best author visit yet." (Lemoyne Elementary, Lemoyne OH)

"Gary Harbo was an outstanding presenter - well organized and inspirational! Please have him return next year!" (Corral Drive Elementary, Rapid City SD)

"Terrific presentation! The kids loved it!" (Cottonwood Elementary, Omaha NE)

"The students were captivated and completely involved. They were excited about their accomplishments." (Old Mission School, San Luis Obispo CA)

"What a great opportunity for our students!! Thank you very much. It was exciting to see and be a part of!" (Roosevelt Elementary, Bismarck ND)

"Gary has a great way of teaching kids. He amazes them with his artistic abilities and more importantly, with their own artistic abilities!" (Prairie View Elementary, Eden Prairie MN)

"Wonderful Job!!! What a pleasure to have a person of Gary's caliber to work with students. He motivates all children and makes them believe that they truly are artists." (Woodbury Elementary, Woodbury MN)

"It was a great presentation! He was a real hit in our building! I would recommend him to any school needing a presenter." (Tecumseh South Elementary, Topeka KS)

Would you like Gary to visit your school?

For availability call: (651) 450-7427

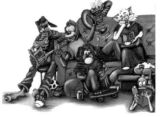

Reading.... Share it with your friends!

Gary Harbo - **Session #1**

Art Lesson - Animal Character Illustrations

Initial Art Lesson: **Two Dimensional Animal Character Illustrations**

Purpose: Teach students the process of creating and illustrating an animal character

Students often feel they cannot draw. This step-by-step art lesson will show even the most skeptical of talents that drawing can be easy and fun. By breaking the illustration down into simple steps, the children will be able to successfully follow along and create a wonderful two dimensional animal drawing. Gary provides a lot of choices, which allows every student to create their very own character with unique personalities. This builds self-confidence and allows children to explore talents that may have been hidden under a blanket of frustration.

Program: Presentation and hands-on drawing exercises

This presentation includes the step-by-step process involved in creating an animal cartoon character. Each child will participate in a 55 minute art lesson and will be delighted with their final drawing. Every student will create their very own two dimensional animal cartoon character.

Just like every artist, each drawing will be unique
and will have an interesting personality.

Program Highlights:
- Each student will create their own character
- Step-by-step drawing lessons
- An autographed original illustration left with each class
- Great for students of all ages
- Up to 50 students can participate in each session

For more information visit Gary's website at
www.garyharbo.com
email: gharbo@garyharbo.com

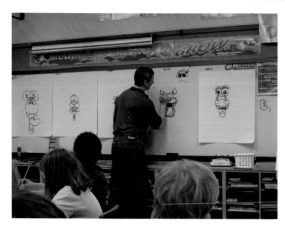